IMAGES *of America*
MASSACHUSETTS STREET

On the Cover: A 1909 parade on Massachusetts Street, known to locals as "Mass Street," features newfangled automobiles and representatives of the Lawrence Automobile Club, Haskell Institute, and the Kansas Fraternal Aid Society. (Courtesy of the Douglas County Historical Society, Watkins Museum of History.)

IMAGES of America
MASSACHUSETTS STREET

Robert C. Dinsdale, MD

ARCADIA
PUBLISHING

Copyright © 2024 by Robert C. Dinsdale, MD
ISBN 978-1-4671-6159-6

Published by Arcadia Publishing
Charleston, South Carolina

Printed in the United States of America

Library of Congress Control Number: 2024935401

For all general information, please contact Arcadia Publishing:
Telephone 843-853-2070
Fax 843-853-0044
E-mail sales@arcadiapublishing.com

Visit us on the Internet at www.arcadiapublishing.com

To Katherine, my love, my life, my best editor, who has taught me so much about a life of faith.

Contents

Acknowledgments		6
Introduction		7
1.	Founding	11
2.	River	21
3.	Buildings	31
4.	Essentials	45
5.	Business	59
6.	Disasters	69
7.	Places	81
8.	People	95
9.	Marching	113

Acknowledgments

I owe a debt of gratitude to all the generations of people who wrote letters, took pictures, and had the courage to save them for posterity. Similarly, others saved, collated, and cataloged these items to make them accessible.

Among the living, I thank Kate Grasse of the Kramer Family Research Room at the Watkins Museum, Kathy Lafferty of the Kenneth Spencer Research Library at the University of Kansas, Rosalee and Peter Carttar of the Fitzpatrick-Postma Collection at the Lawrence Public Library, and historian and author Virgil Dean for their patience, gentle correction, enthusiasm, and encouragement.

INTRODUCTION

Every town needs a heart. More than just a geographic center or a place to administer government or hawk merchandise, every town needs a place where all citizens can cross paths. Every town needs a place where belonging is shared; a place to gather to celebrate, campaign, or complain.

In Lawrence, that place is Massachusetts Street—Mass Street if you are local. It is where the town was founded and formed under great duress. In the first dozen years, the founders of Lawrence built their homes and businesses on Mass Street and then saw them burned to the ground—twice. On Mass Street, they sorted out the results of a fraudulent election, argued their way through four attempts at a state constitution, survived a yearlong drought, and on one dark day of terror, witnessed the massacre of a fifth of their adult men. The men and women on Mass Street saw their state admitted to the Union, endured the Civil War, weathered the assassination of President Lincoln, and chartered a major university.

After the second rebuilding of Lawrence in 1863, the town benefited from the arrival of two railroads and the (eventually) successful harnessing of the mechanical power of the Kansas River. Soon came river-powered electricity, still rare in the West, generated in Lawrence only six years after the Edison Electric Company brought coal-powered electricity to New York City. The resultant manufacturing boom allowed the town to expand along Mass Street. Fine buildings for business, manufacturing, and living extended southward, but in those days, gutter-less Mass Street was either dusty or muddy. Horses, oxen, and wagons were stationed randomly, and the street was littered with wooden crates tossed aside by store owners after their contents were unpacked. Livestock grazed at the south end of the town in South Park.

By 1880, the commercial area of Mass Street had quadrupled in length, extending to Tenth Street where the new Methodist Episcopal Church stood. The horse-drawn coaches that creaked across the wooden bridge from the Union Pacific Railroad depot to the Eldridge Hotel were replaced by a horse-drawn streetcar on rails that traveled from the depot all the way to Eleventh Street and then as far south as Nineteenth Street in 1884. Large bank buildings appeared, reflecting the increased availability of capital for growth. Lawrence began attracting and keeping entrepreneurs such as Mary Barnes, J.D. Bowersock, Albert Henley, and J.B. Watkins.

At the turn of the 20th century, Lawrence hosted exuberant outpourings of pride and patriotism and smoothed its rough edges as well. Troops returning home from the Philippine–American War were feted with a march down Mass Street, and the buildings were dressed with bunting. The semicentennial parade of 1904 featured a merry-go-round at Ninth and Mass Streets. A parade to promote the circus featured a dozen elephants walking tail-to-trunk south on Mass Street. Brick pavement, limestone curbs, and fine horse-drawn carriages graced Mass Street all the way from the river to south of Eleventh Street and livestock no longer roamed South Park.

The complex street-naming system was changed in the early 1900s. East-west streets named for public leaders from New England or Revolutionary War heroes became numbered streets. The original names of the north-south streets remained state names, ordered by date of admission to

the Union with Mass Street at the center. The original colonies, with the obvious omission of Confederate states, are grouped to the east of Mass Street. For simplicity, this book will use the numbered east-west street names.

The first multistory retail buildings began to appear at the turn of the 20th century. They were possible because the local economy, driven by the power of the Bowersock Dam, was growing. The larger more formal retail buildings were accompanied by a formal county courthouse and a city library in 1903 and a bandstand in South Park in 1906.

As businesses continued to be built southward along Mass Street, so did the transport systems providing access. The streetcar system was electrified and extended to Twenty-third Street by 1909. This allowed retail businesses to develop at Fourteenth and Nineteenth Streets. By 1916, underground water pipes and stormwater and sewage systems made for a cleaner and healthier experience along Mass Street.

The entertainment options along Mass Street evolved as well. The Bowersock Opera House first featured local and regional speakers and singers. Vaudeville brought great variety and entertainment in the 1890s. Around 1915, the Dickinson, Patee, Granada, and Varsity movie theaters replaced vaudeville, first featuring silent movies and then talkies in 1927.

Mass Street saw its share of disasters as well. Periodic flooding of the Kansas River either impaired or destroyed the operations of the dam and the businesses dependent on the power produced by the dam. In February 1911, a fire destroyed the Bowersock Opera House, and a tornado struck the same area of Mass Street two months later. Although the stone or brick construction of Mass Street buildings mandated after Quantrill's Raid prevented massive conflagrations, individual structures still succumbed to fire.

Mass Street became more of a thoroughfare in the 1920s and 1930s. National highway routes entered the north end of Mass Street via a concrete bridge built in 1916 across the Kansas River. Haskell Stadium drew thousands of fans to see that institution's nationally ranked football team. The popularity of the automobile brought auto dealerships, auto repair shops, and filling stations to the storefronts of Mass Street. Smooth asphalt pavement and angled parking enhanced the driving experience. The streetcar rails were removed or paved over and replaced by buses. Ironically, the old streetcars were repurposed as individual dwellings in a motor court catering to automobile travelers a few neighborhoods west of Mass Street at 937 Murrow Court.

From 1920 to 1945, the population of Lawrence grew less than one percent per year, and the look of Mass Street was static as well. Although the dam still supplied the newspaper, the paper company, and a grain mill with power, the manufacturing district along the Kansas River declined. The buildings in the manufacturing district at the north end of Mass Street were abandoned or housed a variety of flea markets, secondhand stores, or warehouses.

A wartime population boom came during and after World War II, with an employment surge at the nearby Sunflower Ammunition Plant and an influx of University of Kansas students using their GI Bill benefits. New people brought new ideas, and new ideas meant big change afoot in Lawrence. The conflicts about the costs and benefits of changing would play out over the next 50 years.

From 1945 to 2000, the population of Lawrence increased tenfold, and the modern-day Mass Street emerged. It was no longer the only place in town to shop. Developers drew up plans for shopping malls away from downtown where people could more easily drive and park. For three decades, ideas to enhance Mass Street were passionately debated. Should a shopping mall be sited downtown? What about more parking? What buildings and landmarks should be preserved?

National debates about civil rights, Vietnam War policies, and allowable degrees of personal freedom unfolded on Mass Street. University of Kansas students protested segregation in housing by staging a sit-in at the chancellor's office on March 8, 1965. They were arrested and bused to the courthouse at Eleventh and Mass Streets. The Veterans Day parade down Mass Street on November 11, 1968, was followed half an hour later by an antiwar protest parade that marched in the opposite direction. A commune called Headquarters started at 1546 Mass Street, with the members having a passion for helping youth safely navigate the drug culture. They tested street drugs for contamination and put the word out on what drugs to avoid.

The collision of competing ideas turned violent once again in Lawrence in 1970. After a five-day period of multimillion-dollar fires set by arsonists at 930 Mass Street, the student union at the University of Kansas, and the Lawrence Public Schools administration building, the state imposed martial law April 21–23, 1970, with a dusk-to-dawn curfew. Dozens of sniper fire incidents were reported and at least one Mass Street business owner stayed in his office overnight, shotgun on his lap. Two young men were shot and killed by Lawrence police the week of July 16–23, 1970. People feared for their lives.

Peace returned with the passage of time, active listening, and changes in policy. The appearance of Mass Street evolved once again as urban renewal reshaped downtown into a more pedestrian-friendly place. Planters and sawtooth curb cuts allowed for more trees and wider sidewalks. Narrower traffic lanes slowed car traffic. New sewers, new light poles, and those blasted parking meters completed the streetscape. A new city hall and new Kansas River bridges reconfigured the north end of Mass Street. Local investors Charles Oldfather and David and Susan Millstein sparked a new interest in building preservation when they resurrected Liberty Hall at 644 Mass Street as well as the Barteldes building at 804 Mass Street and the Casbah at 803 Mass Street. The county courthouse got a new slate roof, new windows, and an elevator in 1978. In 1989, Chuck Magerl successfully lobbied to rescind Kansas laws prohibiting breweries and then birthed his own long-profitable Free State Brewing Company at 636 Mass Street in a refurbished bus station. A public-private partnership made the Eldridge Hotel a site of fine accommodations once again after a 15-year stint as a senior living center.

On this reconfigured landscape of Mass Street, 70,000 people high-fived and exuberantly screamed their delight at the accomplishments of the University of Kansas 2008 and 2022 national champion men's basketball teams. The tidal wave of humanity was large enough to require the repositioning of emergency vehicles in the city, as traversing this pulsating gyre of happy humans was impossible. People knew there was only one place to be to share their joy. They came to the heart of their city, Mass Street.

One

FOUNDING

Kansas Territory was opened to Euro-American settlement on May 30, 1854, and Lawrence had its first settlers two months later. Several squatters were already here when the New England Emigrant Aid Company obtained the land that had been assigned to the Shawnee tribe. The company's goal was to settle Kansas with enough men to win the political battle to create a state constitution banning slavery as well as to build a prosperous community. They platted the town on the southern bank of the Kansas River, down the hill from the Oregon Trail, where there was a source of water, timber for buildings, and potential for river power and river transportation. This site is now where Massachusetts Street crosses the river.

Mass Street grew as the town of Lawrence grew. Crude timber buildings gave way to more substantial two- and three-story limestone ones that extended the community south for two blocks. Saddlers, blacksmiths, general stores, newspapers, and a grain mill were the early businesses. Within 10 years, the population of Lawrence was 1,600 people. One-fourth of those residents were New Englanders; one-fourth were Westerners from Iowa, Indiana, Illinois, and Ohio; one-fourth were Southerners and Missourians; and one-fifth were foreign-born. The diverse factions fought among themselves, sometimes violently, over land ownership rights, but in their opposition to slavery, they were a united front. The phrase "Bleeding Kansas," coined by Horace Greeley of the *New York Tribune*, aptly described the brutal strife consummated early in Lawrence on Mass Street that ultimately plunged the nation into Civil War.

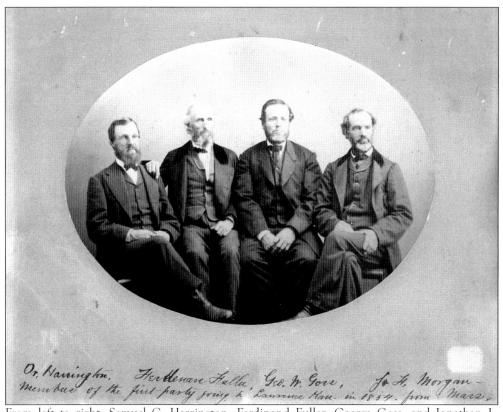

From left to right, Samuel C. Harrington, Ferdinand Fuller, George Goss, and Jonathan L. Morgan were in the first group subsidized by the New England Emigrant Aid Company to settle in Lawrence on August 1, 1854. New Englanders opposed to slavery came first, with the rest coming from foreign countries or from the southern or western regions of the country seeking economic opportunity. (Courtesy of the Kenneth Spencer Research Library, University of Kansas.)

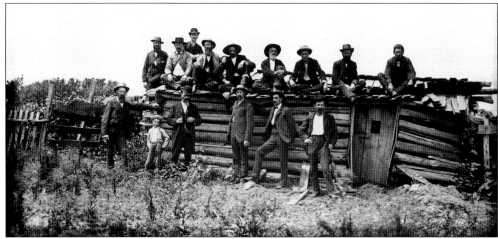

Timber next to the Kansas River was the first material used for shelter in the fall of 1854. The Free State Hotel, also of wood construction, was built in 1855 on Mass Street by the New England Emigrant Aid Company to house new immigrants until they could arrange for suitable housing. (Courtesy of the Kenneth Spencer Research Library, University of Kansas.)

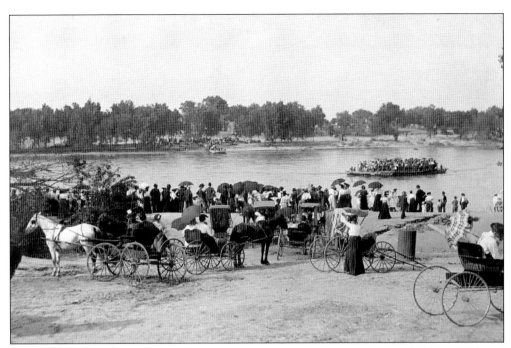

A rope-drawn ferry, located where the Mass Street bridge is now, transported people and materials across the river beginning in 1855. Ferry charges were in the modern range of $3 to $10 per person or animal. A toll bridge replaced the ferry in 1863. This 1903 photograph shows a ferry used after the bridge was destroyed by a flood. (Courtesy of the Douglas County Historical Society, Watkins Museum of History.)

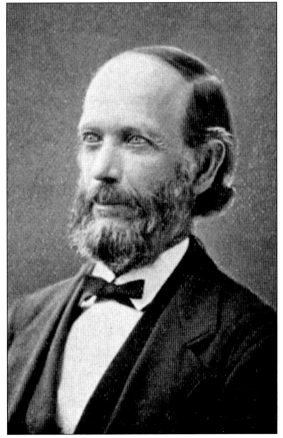

Joseph Savage and his brother came to Lawrence in the fall of 1854. On the journey, they played music with other travelers. They continued that tradition in Lawrence and formed the Lawrence City Band, performing in the plaza next to the jail at Sixth and Mass Streets where Robinson Park is today. This image is from *A History of Lawrence, Kansas* by Richard Cordley, published in 1895.

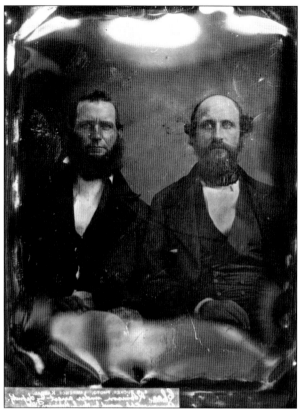

Charles Robinson helped select the townsite and was an early abolitionist leader. Robinson (right) is shown with his jailer after his arrest on May 10, 1856, for failing to follow the edicts of a proslavery judge in Lecompton. Two weeks later, the proslavery sheriff from Lecompton, along with militias from Missouri, came to Lawrence and burned the hotel. (Courtesy of the Kenneth Spencer Research Library, University of Kansas.)

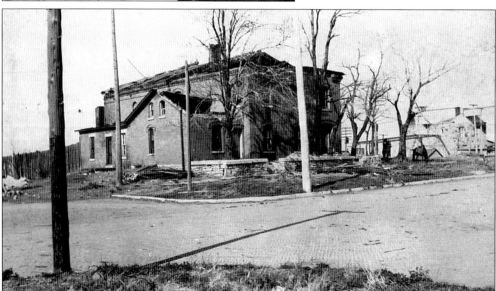

The jail, constructed in 1859 and sited at the north end of Mass Street, was the first building in Lawrence designed by John G. Haskell. Haskell also designed the courthouse, the John Roberts Castle, and several commercial buildings downtown. The jail is shown after it was abandoned and then damaged in the 1911 tornado. The bridge is to the right. (Courtesy of the Douglas County Historical Society, Watkins Museum of History.)

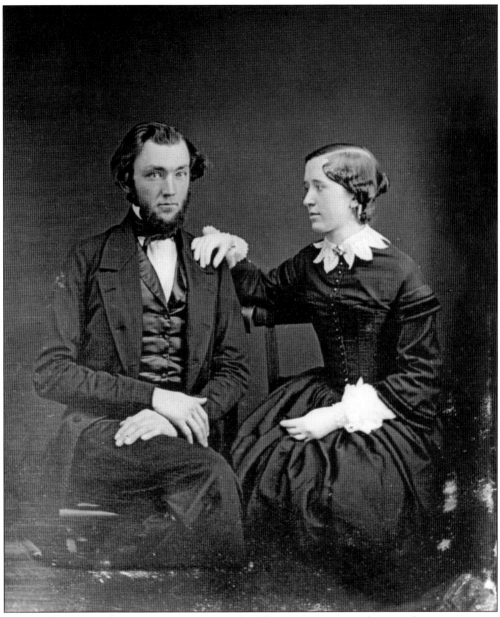

Josiah and Agnes Miller came to Lawrence in the fall of 1854. He started an antislavery newspaper that was declared a public nuisance in 1856 by a proslavery grand jury in Lecompton; a warrant was issued for his arrest. After pleading his case, Miller was accosted by a posse on the road back to Lawrence, threatened with hanging, and relieved of his horse and money. His parents moved to Lawrence in 1858 after leaving the South because of their opposition to slavery. Josiah and his father, Robert, were entrepreneurs who built Miller's Hall at 723-725 Mass Street in 1858 as a place for political and church meetings as well as a business site. It was partially destroyed on August 21, 1863, during Quantrill's Raid; the salvaged building remains on Mass Street. Josiah also helped found the Free State Party and served as a state legislator. Some authorities credit him as the creator of the state motto *Ad Astra Per Aspera*. He was postmaster of Lawrence in 1863. (Courtesy of the Kenneth Spencer Research Library, University of Kansas.)

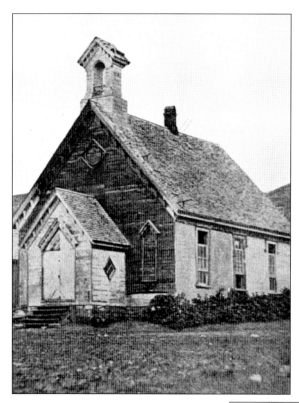

The First Methodist Episcopal Church, built in 1858 on Vermont Street, served as the morgue in August 1863, after Quantrill's Raid. The church moved to a new building on Mass Street the following year. The wooden structure on Vermont then became a private residence. (Courtesy of the Kenneth Spencer Research Library, University of Kansas.)

The new Methodist Episcopal Church at 1001 Mass Street opened in 1864. At the time, this was considered the edge of the downtown area, with a lumberyard across the street and open land next door. The church remained here until 1891, when it moved to its present building a block away. (Courtesy of the Douglas County Historical Society, Watkins Museum of History.)

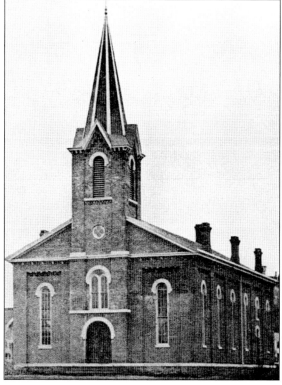

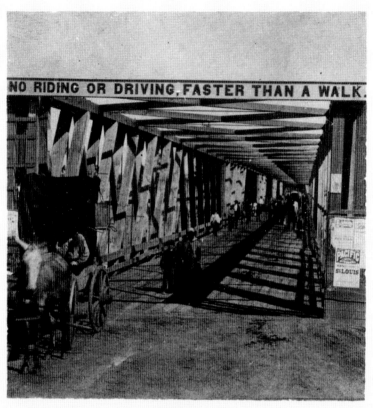

1868

The nearly finished toll bridge at the base of Mass Street provided refuge for some Lawrencians during Quantrill's Raid in 1863. It was the first river bridge west of Kansas City. The next bridge built in the area was the Hannibal Railroad bridge across the Missouri River in Kansas City five years later. The Mass Street bridge was strong enough for animals and wagons; but, as the sign indicates, it was not built for rapid transit. By the time of this photograph in 1868, the Union Pacific Railroad was serving north Lawrence. Horse-drawn carriages then started making the circuit from the railroad depot to the Eldridge Hotel. The toll bridge served for 15 years until the Supreme Court of Kansas revoked its charter and confiscated the bridge to make it toll-free. The wood timbers were gradually replaced with steel. The timber bridge surface was replaced by brick over time. In 1871, rails were laid down on the center of the bridge, and streetcar service commenced. (Courtesy of the Kenneth Spencer Research Library, University of Kansas.)

From his arrival in 1877, J.D. Bowersock, "Master of the Kaw," was a leading force for the industrialization of the north end of Mass Street. Bowersock built the first successful dam to harness the power of the river and then invested in the businesses that would use the power, including the Lawrence Paper Company, Bowersock Iron Works, and Bowersock Mills. (Courtesy of the Kenneth Spencer Research Library, University of Kansas.)

J.H. Gower, the father-in-law of J.D. Bowersock, built Lawrence's first grain mill, the Douglas County Mills, in 1874. It used river power carried from a dam to the mill via cables and pulleys. The mill stood near where city hall now sits. A flood destroyed the dam in 1877, and the mill was washed away in the flood of 1903. (Courtesy of the Douglas County Historical Society, Watkins Museum of History.)

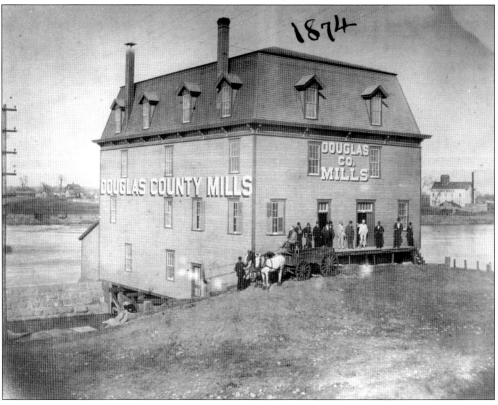

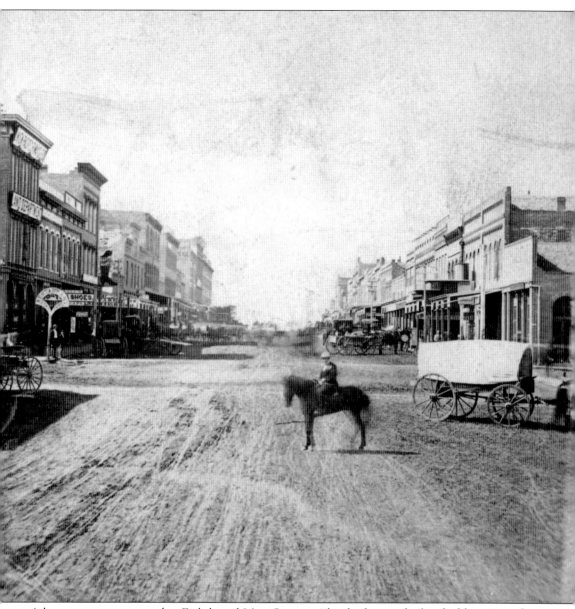

A horseman turns around at Eighth and Mass Streets with a background of parked buggies and wagons in this photograph from the late 1860s. Lawrence had about 8,000 residents then and was half the size of Leavenworth, the largest city in the state. The Eldridge Hotel, renamed for its new owner and rebuilt with an additional floor after its destruction in 1863, is the tall structure left of center. Nearly all the structures in the photograph were newly built after the original two-block Mass Street business district was burned. They are made of stone or brick to lessen the likelihood of widespread fire. The unimproved surface of Mass Street even limited the type of fire engine the city could use; a large one was useless because it sank in the mud. Stores sold stoves, shoes, groceries, and baked goods. Saloons, banks, and tailor shops made up the service industry. The circulating library of the Lawrence Library Association operated on the second floor of the three-story building at left. (Courtesy of the Douglas County Historical Society, Watkins Museum of History.)

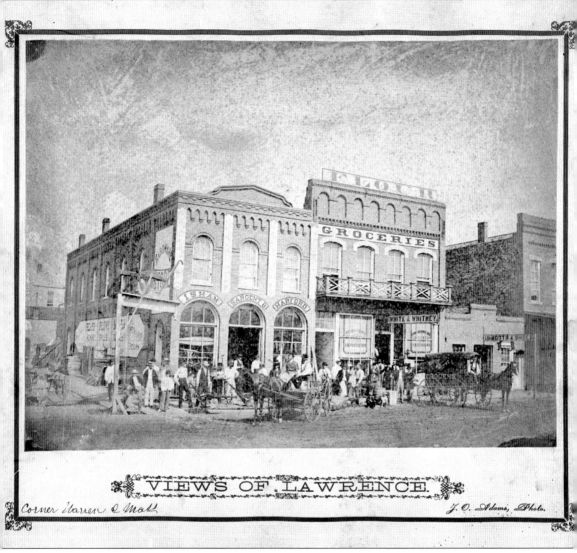

In 1871, the northwest corner of what is now the center of the business district at Ninth and Mass Streets featured plow sales at the Isham Sargent & Harford hardware store and the delivery wagon of the White & Whitney grocery store. This was the year a horse-drawn streetcar began operating from this corner all the way to the Union Pacific rail station across the river. (Courtesy of the Douglas County Historical Society, Watkins Museum of History.)

Two

River

Lawrence is and was and ever shall be a river town. The river is Lawrence's lifeline for food, water, transportation, power, recreation, and, unavoidably, waste disposal. The river meets the town where Mass Street begins, on the south bank of the Kansas River. The south bank was chosen for the townsite because of its higher elevation and accessibility to the Oregon Trail, which passed on the ridge of Mount Oread.

During the 1500s through the 1700s, Native Americans known as the Kaw or Kanza controlled most of the northern third of present-day Kansas and depended on the Kansas River. With the Louisiana Purchase of 1803, nearly all of the Great Plains from the Mississippi to the Continental Divide became US territories. The Kaw were displaced, and Native Americans from the eastern United States were relocated, often forcibly, to these lands. When Euro-American settlers arrived, they also saw the river as a source of water, timber, and food. Additionally, they envisioned capturing the power of the Kansas River for industry and using it as a commercial shipping route. Steamboats operated intermittently on the Kansas River until 1866.

The Kansas River, known often by its nickname, the Kaw, exhibits entirely different behavior than the more predictable New England waterways the earliest Kansas settlers knew. The deceptively dangerous flow of the Kaw alternates between extremes, sometimes producing destructive flooding followed soon by depressing drought. Hidden under a languid surface lie broken trees, ready to perforate a vessel or snag a swimmer. Strong currents capsize the unsuspecting. Winter ice cracks without warning and suddenly gives way.

The ebbing, flowing, ever-changeable Kaw remains an influencer of Lawrence and Mass Street even as their dependence on the river has diminished over the years. This river town's roots continue to define the city.

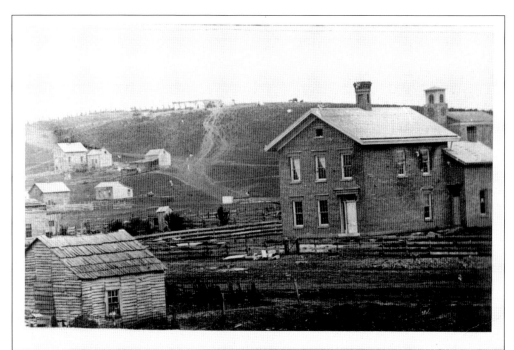

Vermont House at 945 Kentucky Street, Unitarian Church with clock and bell in the tower at the rear and on Ohio street.

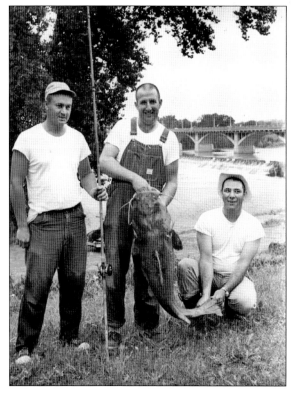

Two decades after the establishment of Lawrence, most of the timber along the Kansas River near town had been cut down and milled to construct commercial buildings along Mass Street and homes extending up the flanks of Mount Oread, where the new University of Kansas structures were sited. (Courtesy of the Kenneth Spencer Research Library, University of Kansas.)

Commercial fishing came to town with the placement of the first substantial dam in 1874. Huge catfish, documented at 175 pounds and rumored as large as 250 pounds, lurked at the base of the dam. Jake Washington, one of the pair of eponymous fishermen commemorated at the venue Abe and Jake's Landing, died trying to land a huge catfish he had hooked. (Courtesy of the Kenneth Spencer Research Library, University of Kansas.)

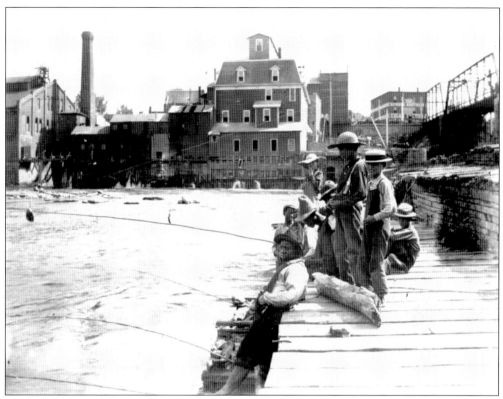

This 1902 photograph shows a group of boys fishing below the dam. In the background are, from left to right, the Douglas County Mills; the new Boener Brothers Cigar Factory at 601–607 Mass Street, equipped with electric lights; and the steel-truss bridge, which had replaced the wooden toll bridge. (Courtesy of the Douglas County Historical Society, Watkins Museum of History.)

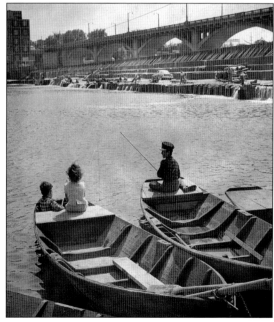

In the summer of 1955, the river level was so low that Lawrencians drove their cars loaded with fishing gear onto the exposed bedrock at the base of the dam. Panels, propped up by wood poles, crossed the top of the dam and created a deeper pool upriver to keep the generators turning beneath the south end of the Mass Street bridge. (Courtesy of the Kenneth Spencer Research Library, University of Kansas.)

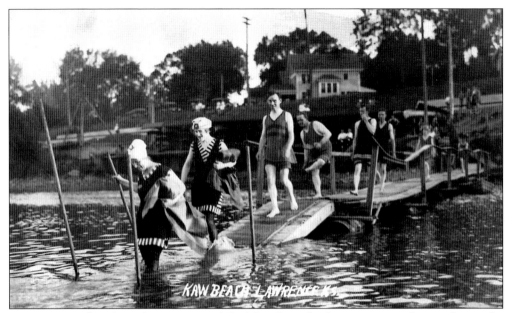

In 1917, a sandbar formed just upriver of the Mass Street bridge, creating perfect conditions for swimming in the river. Since, at the time, there was no swimming pool in Lawrence, this was a delightful serendipity. An improvised dock took bathers over the mud at the shore and into the cool waters. It became known as Kaw Beach. (Courtesy of the Fitzpatrick-Postma Collection, Lawrence Public Library.)

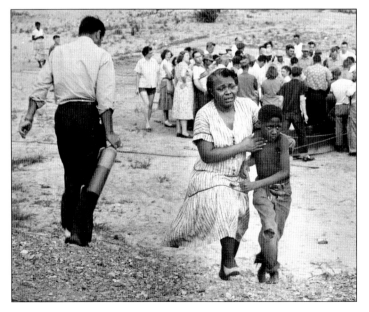

In 1955, the only large pool in Lawrence, the Jayhawk Plunge, was privately owned and segregated. Blacks swam in the Kansas River. Wray Jones, a 12-year-old young Black man, died swimming in the river. Here, Jones's grandmother Mabel Powell (center) and his brother Amos Jones mourn his death. Twelve years later, Lawrence passed a bond issue for an integrated public pool. (Courtesy of the Kenneth Spencer Research Library, University of Kansas.)

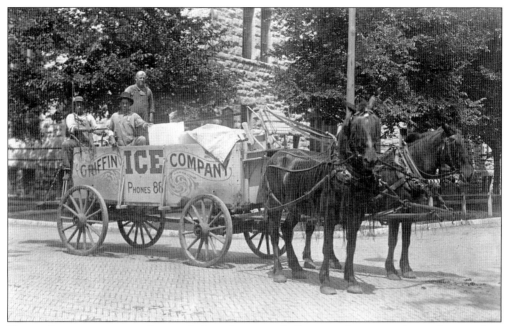

Kansas River ice was sawed, grappled, and extracted all winter long in order to be stored in insulated warehouses and then shipped to homes in the area throughout the spring, summer, and fall. Beginning in 1894, Griffin Ice Company at 616 Vermont Street used electricity from the dam to manufacture ice. By 1902, the company monopolized the ice business. (Courtesy of the Douglas County Historical Society, Watkins Museum of History.)

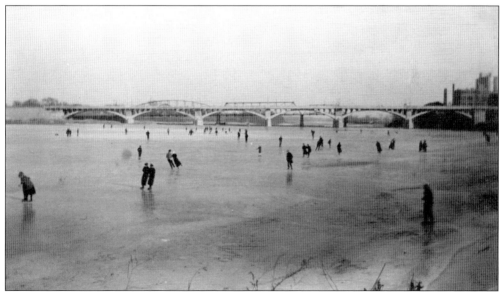

The smooth and quiet waters upriver from the dam and Mass Street bridge froze in the 1920s, and ice skating was a popular form of recreation. The skaters would warm themselves at bonfires on the southern bank of the Kansas River. In the background is the concrete bridge built in 1916 to replace the metal truss bridge behind it. (Courtesy of the Douglas County Historical Society, Watkins Museum of History.)

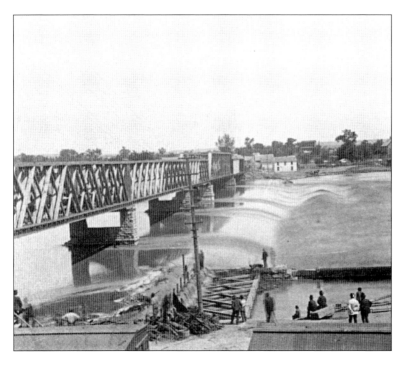

Onlookers gather between the toll bridge and the mill to see water pour over the dam during the flood of 1876. Limestone pediments, several of which survive to the present, resisted the destructive flow. Midway across the bridge was the site of the lynching of three Black men six years after this photograph. (Courtesy of the Kenneth Spencer Research Library, University of Kansas.)

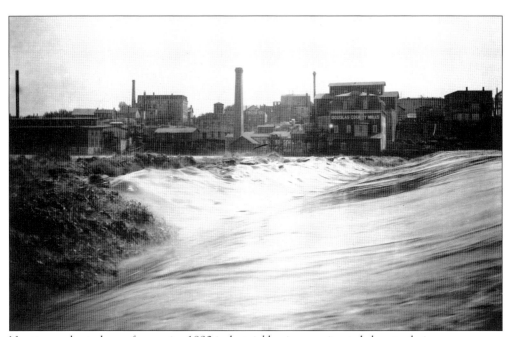

Next to smokestacks are four major 1892 industrial businesses situated close to their power source, the Bowersock Dam at the base of Mass Street. From left to right are the Consolidated Barb Wire Company, the Wilder Brothers Shirt Factory, the US Iron Company, and the Douglas County Mills. (Courtesy of the Kenneth Spencer Research Library, University of Kansas.)

Mary Barnes was an entrepreneur and commercial seamstress who built 826 Mass Street in 1883. Her sewing machines ran on waterpower from the dam transferred to her structure via belts and pulleys running through a ditch behind the buildings. After 1888, a new dam produced electricity. Barnes emigrated from Ireland as a child during the Irish Potato Famine. (Courtesy of the Kenneth Spencer Research Library, University of Kansas.)

The power generation that benefited Mary Barnes's business supported a concentration of industry east of Sixth and Mass Streets, as seen in this aerial photograph from 1950. The Atchison, Topeka & Santa Fe tracks bisect the district, and the Mass Street bridge is the route for US Highways 59 and 40 so that manufacturers' raw materials, power, production, and distribution come together. (Courtesy of the Douglas County Historical Society, Watkins Museum of History.)

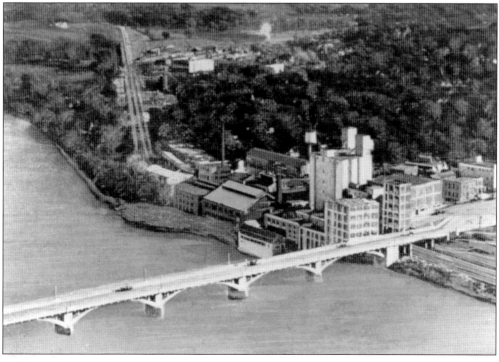

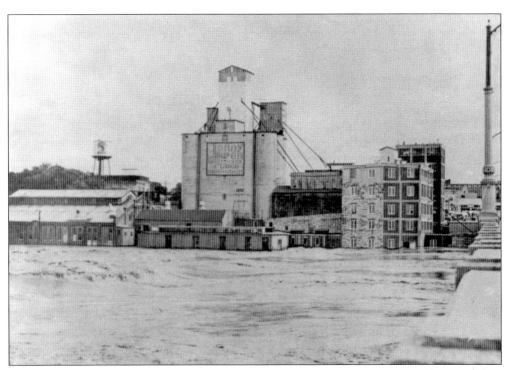

Above, a 1950 photograph presents a view toward Mass Street from the bridge with, from left to right, the tin roofs of the abandoned barb wire factory, the water tower of the Lawrence Paper Company, the grain bins of Jenny Wren Flour, and the brick five-story buildings of Zephyr Flour. Jenny Wren Flour gave its name to the radio station WREN, on the air until 1987. In 1977, a total of 105 years after the city council ceded control of the dam and the levee to a private business, a new agreement returned that authority to the city. Unused industrial buildings were torn down in 1980, and their foundations were used for a new city hall, at right in a 2023 photograph below. The barbwire factory was restored as an event venue. (Above, courtesy of the Douglas County Historical Society, Watkins Museum of History; below, author's collection.)

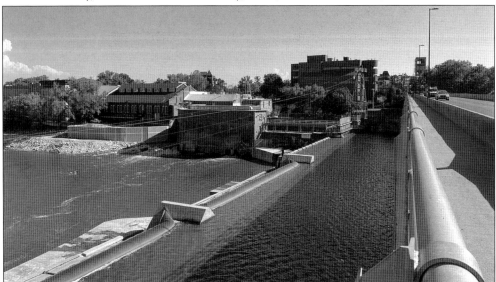

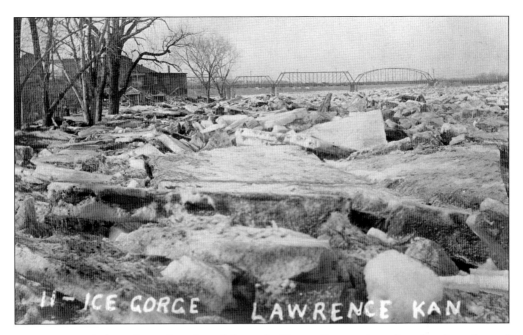

In January 1910, huge floes of ice floated down the Kansas River and combined with ice formed behind the dam. The resulting six-mile-long ice gorge spanned the entire river for several weeks. Piles of broken ice plugged the river and caused localized flooding, damaging the Mass Street bridge and the dam. The flooding disrupted train traffic on the Santa Fe tracks, and the ice piles knocked fish right out of the water and onto the riverbank. Curious onlookers ventured out onto the ice gorge. Attempts to break up the mass of ice using dynamite were of little avail. (Above, courtesy of Kenneth Spencer Research Library, University of Kansas; below, courtesy of the Fitzpatrick-Postma Collection, Lawrence Public Library.)

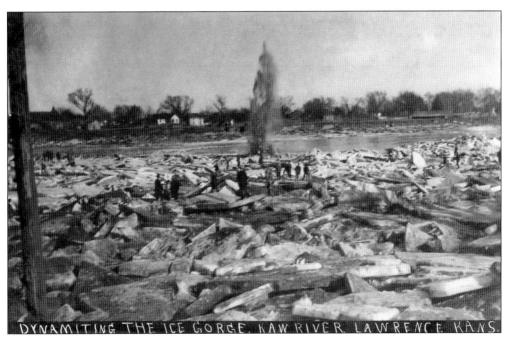

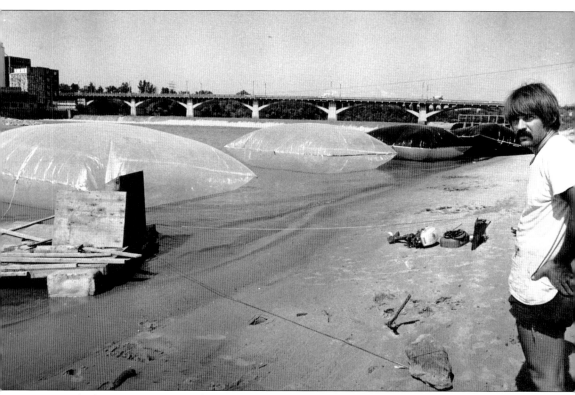

Local adventurer Dan Wessel set off on his Kansas River journey below the Mass Street bridge on August 2, 1973. He is shown with his wooden raft, four attached inflatables, a four-and-a-half horsepower outboard engine for navigation, and a tank of gasoline. He made it 26 miles downriver to Bonner Springs that day before high winds made the floats uncontrollable. (Courtesy of the Kenneth Spencer Research Library, University of Kansas.)

Three

BUILDINGS

A walk down Mass Street is a stroll through a century and a half of stories; there are tales of tragedy and triumph, building and rebuilding. No original wood structures from 1854 are left after the various calamities of weather, fire, and tornadoes, but the typical brick and limestone two-story buildings of downtown Lawrence are almost that vintage, many dating to the late 1800s. Those were the years when Mass Street was rebuilding and expanding after Quantrill's Raid and the Depression of 1873 through 1878. The buildings reflect the wealth and optimism of the time, much of that owing to the power flowing straight from the Bowersock Dam.

In 1949, the towering Victorian-style Lawrence National Bank building at 645 Mass Street was demolished to make room for what was then considered a modern bank, a short curved-corner edifice of stone, metal, and glass. That 1950 building remains, now with filled-in drive-through lanes behind a new facade. Similarly, in 1969, a series of century-old Italianate buildings in the east 900 block of Mass Street were razed to make way for a modernistic bank tower.

Beginning in the 1960s, the north end of Mass Street was deindustrialized and repurposed. The 1980 cylindrical city hall mimics the concrete grain silos that previously overlooked the river. The original circular silo bases lie just north of the building. The stylistic anchors at the south end of downtown are the 1888 Watkins Bank building and the Douglas County Courthouse, constructed on land donated by J.B. Watkins in 1903.

Most of the structures on Mass Street have had multiple identities. A grocery store became a bakery; a barbershop became a clothing store. And then there was the billiard hall that woke up as a mortuary. Only a few, including Liberty Hall and the Eldridge Hotel, have stayed mostly true to their original functions.

South on Mass Street, the magnificent home called The Castle, the retail buildings at Fourteenth and Nineteenth Streets, the frame homes built after 1909, and the campus of Haskell Indian Nations University all contribute to the story that Mass Street tells.

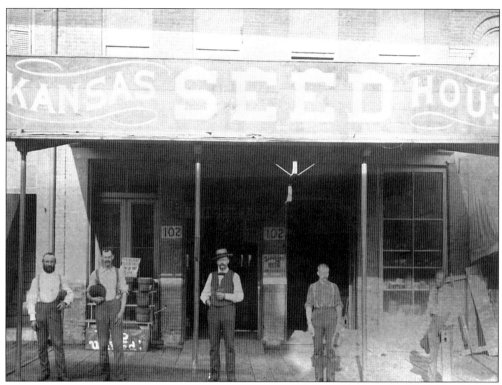

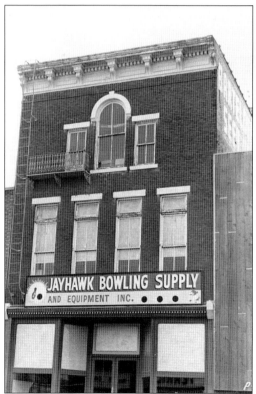

Peter Ridenour and Harlow Baker built 804 Mass Street for their grocery business in 1860. The building burned in Quantrill's Raid, and Ridenour reopened three days later by himself. His business partner, Harlow Baker, was severely wounded. Their grocery store grew into a grocery supply business and moved to the West Bottoms of Kansas City in 1878. The Kansas Seed House then occupied 804 Mass Street. Founded by Friedo Barteldes, a German immigrant, the mail-order business grew to become the largest seed supply company in the western United States. In 1906, it incorporated as the Barteldes Seed Company and expanded to Denver and Oklahoma City. After the seed company moved from Mass Street in 1961, the building housed the Jayhawk Bowling Supply Company. (Above, courtesy of the Douglas County Historical Society, Watkins Museum of History; left, courtesy of Kenneth Spencer Research Library, University of Kansas.)

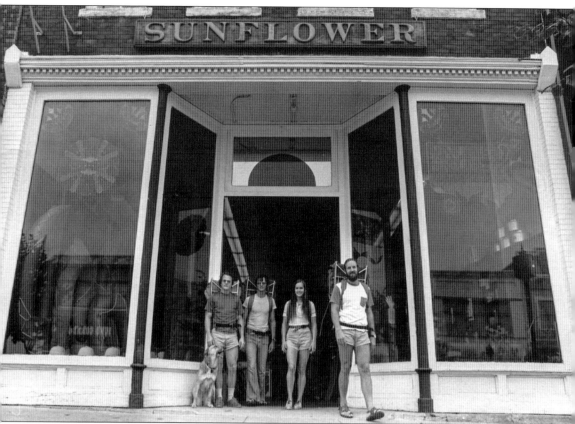

Susan and David Millstein (right) are shown in 1972 when they moved Sunflower Surplus to 804 Mass Street. The enterprising Millsteins had started an Army surplus store in Lawrence a few years earlier similar to the one David's father had in Kansas City. Then they got on the wrong side of Kansas drug laws. While in Morocco, the Millsteins purchased 66 pounds of hashish with a street value of $250,000, concealed it in a van purchased in Europe, shipped it to Houston, and drove the van to Lawrence. Police, acting on a tip, arrested them on April 8, 1971, and charged them with transporting the concentrated cannabis. They sold store inventory to pay their $100,000 fine. A year later, starting with the surplus and outdoor store, they began to transform Mass Street. They restored 636–646 Mass Street, which became Liberty Hall, Free State Brewery, La Prima Tazza, and the original Raven Bookstore. At 802 Mass Street, they added a bike shop to the outdoor store. Their property at 803 Mass Street became the Casbah. (Courtesy of Dan Hughes.)

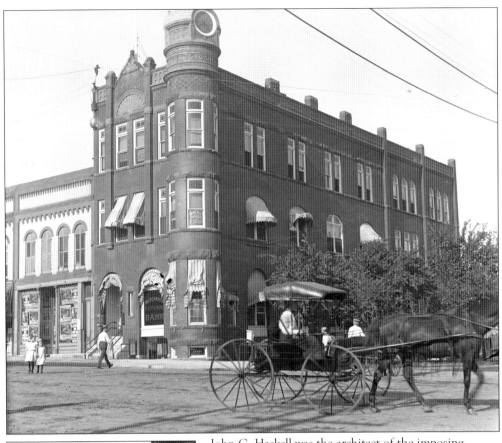

John G. Haskell was the architect of the imposing redbrick Merchants National Bank. Its clock tower dominated the Lawrence skyline from the northeast corner of Eighth and Mass Streets from 1888 until 1930. The brick pavement and the horse and carriage on the street date this photograph to the 1890s. (Courtesy of the Douglas County Historical Society, Watkins Museum of History.)

The Merchants National Bank failed in 1930 and was reorganized as the First National Bank. The clock tower and top floor were removed and the bank widened into 744 Mass Street. Legend has it that Clyde Barrow's first bank heist was there in 1932. The bank, shown in 1960, moved to 902 Mass Street in 1970. After 1992, the space held bank-themed eateries. (Courtesy of the Kenneth Spencer Research Library, University of Kansas.)

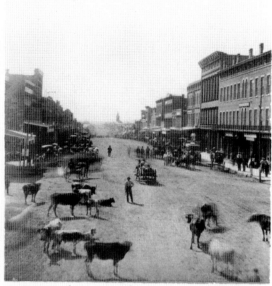

Above, an 1868 photograph shows the three-year-old brick Eldridge Hotel on the right and the Methodist church steeple in the distance. The hotel was rebuilt by Shalor Eldridge using public and private money after the 1863 fire. Animal grazing was allowed in South Park, so livestock loose on Mass Street is no surprise. Below, the Eldridge Hotel is a hub of activity in 1868 with a barbershop, the Union Pacific ticket office, an ice company, a title company, and a real estate company. Telegraph wires (seen in the foreground) served a Great Western Telegraph office. Coach drivers were ready to take patrons across the Mass Street bridge to the railroad station. (Both, courtesy of Kenneth Spencer Research Library, University of Kansas.)

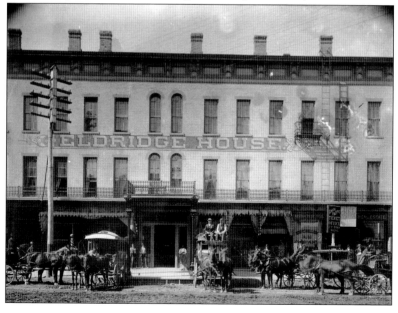

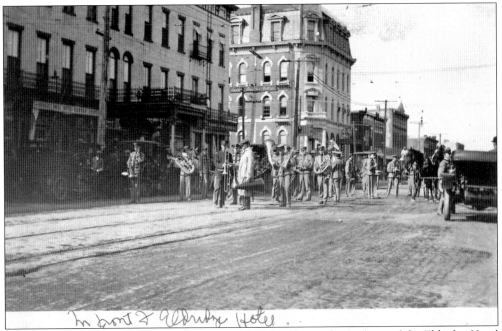

A band, perhaps the University of Kansas marching band, parades in front of the Eldridge Hotel around 1915. The Eldridge was then the premier hotel in the town of 12,000 people. A decade later, the hotel was failing. The structure was razed and later rebuilt with public and private money. In the background is the Lawrence National Bank, which housed the Lawrence Business College. (Courtesy of the Fitzpatrick-Postma Collection, Lawrence Public Library.)

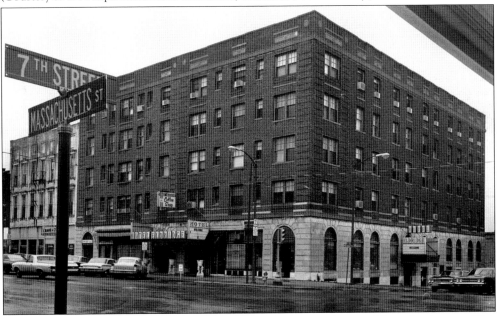

Thirty-five years after its third reincarnation, the Eldridge Hotel again fell on hard times. This 1970 photograph was taken the year the hotel closed and the building was converted to senior housing. Major renovations in 1985 and again in 2005 restored the Eldridge Hotel as a premium hotel. (Courtesy of the Kenneth Spencer Research Library, University of Kansas.)

The Eriksen store at 936 Mass Street sold stoves, rugs, beds, and furniture. In 1900, rugs were displayed over the sills of the second-story windows. A century later, the space housed the revered vinyl record vendor Love Garden Sounds. None other than Kurt Cobain crossed the store's iconic squid mosaic to flip through the vast collection of recordings new and old. (Courtesy of the Kenneth Spencer Research Library, University of Kansas.)

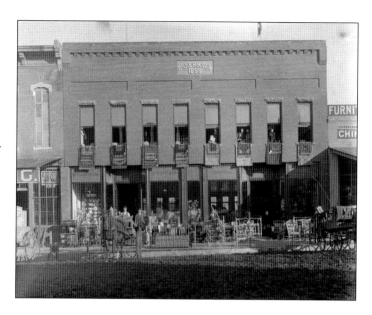

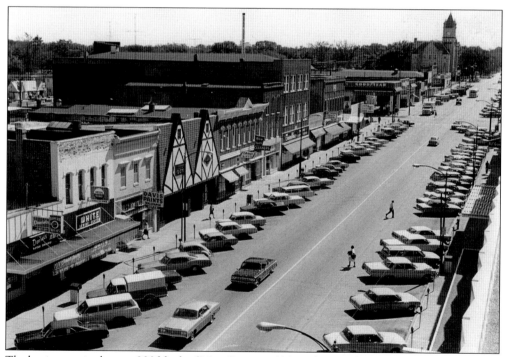

The businesses in the east 900 block of Mass Street in 1967 reflect its place as the primary retail area for Lawrence. From left to right are Daniels Jewelry, White Sewing Center, Davis Paints, Mister Guy Clothing, Elring's Gifts, Sutton AudioTronics, Gambles Furniture, New York Cleaners, Lawrence Beauty School, Sherwin-Williams Paints (in the Eriksen Building), Credit Thrift of America, and Goodyear Tire. (Courtesy of the Kenneth Spencer Research Library, University of Kansas.)

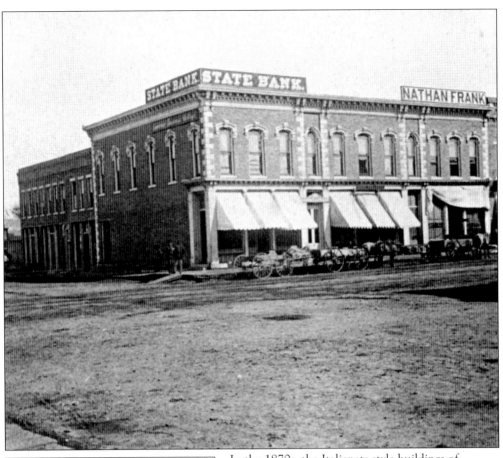

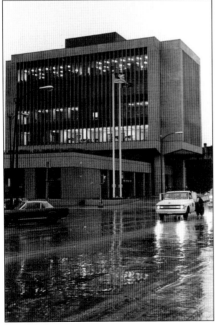

In the 1870s, the Italianate-style buildings of 900–904 Mass Street housed the State Bank, Poehler's Grocery, and Nathan Frank Grocery. Mass Street was dirt, and the sidewalks were wooden. Poehler's was owned by Theodore Poehler, who later expanded the business to a wholesale grocery operation at 619 East Eighth Street. The buildings remained at Ninth and Mass Streets until 1969. (Courtesy of the Kenneth Spencer Research Library, University of Kansas.)

The new First National Bank and office tower brought major change to Ninth and Mass Streets in 1969. It was designed by the same firm that created Arrowhead Stadium and that era's terminals at the Kansas City International Airport and is firmly in the Modernist style. The bank and city hall were the first occupants of the building. (Courtesy of the Kenneth Spencer Research Library, University of Kansas.)

Liberty Hall got its name from an Abraham Lincoln speech calling Lawrence the "Cradle of Liberty." It was built in 1870 at 644 Mass Street, the site where the abolitionist *Herald of Freedom* newspaper press was destroyed by a proslavery militia in 1856. Liberty Hall was a public events venue for entertainment, political speeches, and town meetings for 40 years. (Courtesy of the Douglas County Historical Society, Watkins Museum of History.)

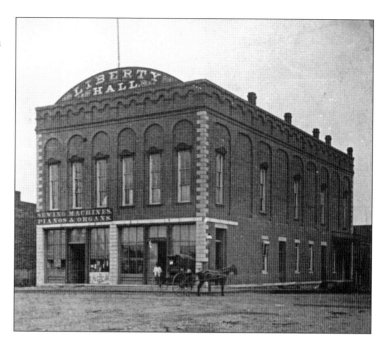

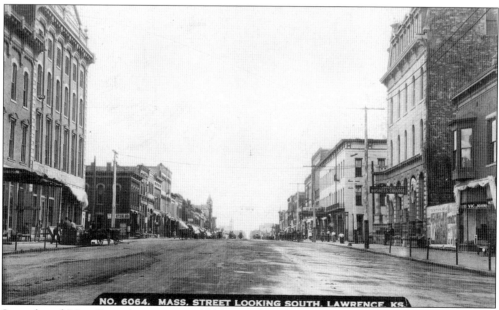

Seventh and Mass Street businesses in 1904 were, from left to right, the Bowersock Opera House, American Cement Plaster, the Eldridge Hotel, and the Lawrence National Bank. J.D. Bowersock purchased Liberty Hall in 1882 and added a story and his name to the building. The *Lawrence Journal* offices were on the first floor with performance space above. The hall burned in 1911. (Courtesy of the Douglas County Historical Society, Watkins Museum of History.)

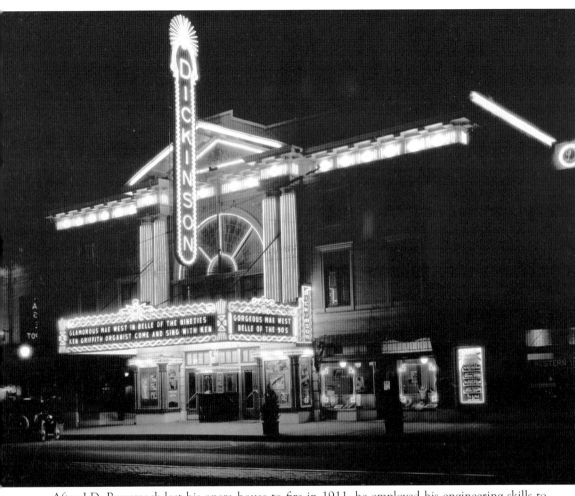

After J.D. Bowersock lost his opera house to fire in 1911, he employed his engineering skills to build a fireproof concrete block and masonry structure that opened on January 22, 1912. Inside, he improved the acoustics and decorated the walls and ceilings with murals. Then he clad the outside with Beaux-Arts detailing. It was a community space, used for high school graduations and political speeches. After Bowersock's death in 1922, the new owner hosted the state convention of the Ku Klux Klan in 1924. Dickinson Theatres bought it in 1925, shuttered the silent movies, and introduced talkies. Two notable films have premiered there, *Dark Command* in 1940, based on the story of Quantrill's Raid and starring John Wayne, and *Jayhawkers* in 2014, directed by Lawrencian Kevin Willmott. Live performances evolved from operettas to the likes of B.B. King, Ike and Tina Turner, Nickel Creek, and Hanson. The venue fell on hard times in the 1980s and was going to be torn down before it was restored in 1986 and once again named Liberty Hall. (Courtesy of the Kenneth Spencer Research Library, University of Kansas.)

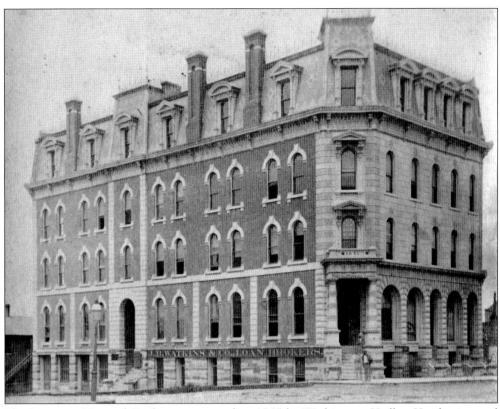

The Lawrence National Bank was organized in 1865 by Washington Hadley. He also invested in the first Kansas River dam, built in 1872. The bank constructed a Victorian-style four-story building (seen above) at 647 Mass Street. The J.B. Watkins land mortgage business was on the first floor. The Lawrence City Library occupied three rooms from 1873 until 1904 then moved to the Carnegie Library. The old building was razed in 1949 to make way for a new modern one (pictured below) with a motor bank, reflecting the importance of the automobile in everyday life. The bank merged with another institution in 1992 and sold the building. A new facade was added when the structure was rebuilt for retail space in the 1990s. (Above, courtesy of Kenneth Spencer Research Library, University of Kansas; below, courtesy of the Douglas County Historical Society, Watkins Museum of History.)

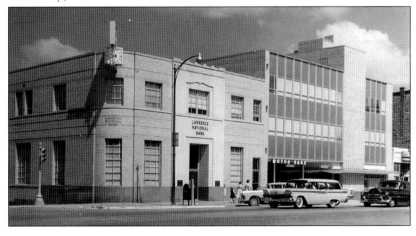

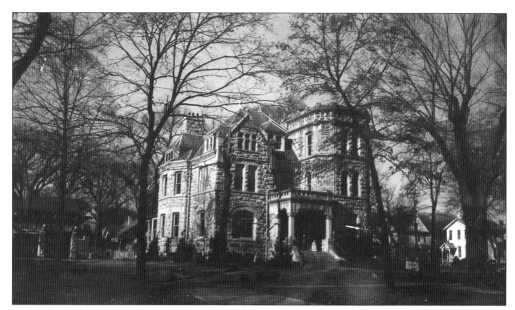

Col. John Roberts, a Civil War veteran, owned the Kansas Basket Manufacturing Company, which annually produced more than two million wooden boxes used for the shipment and storage of butter, lard, and fruit. Roberts hired John G. Haskell to design his home, The Castle, at 1307 Mass Street. It was built during 1893 and 1894; a 20-year-old artist from England did all the interior carving. (Courtesy of the Douglas County Historical Society, Watkins Museum of History.)

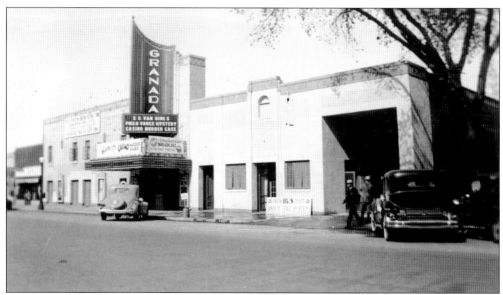

The new Granada movie theater at 1020 Mass Street is shown here in 1935 in the middle of the Depression. Like all movie theaters in Lawrence at the time, it was segregated. It started as a vaudeville theater in the 1920s, showed movies from 1935 until 1995, and offered live music in the 1990s. On the right is a second downtown bus station. (Courtesy of the Douglas County Historical Society, Watkins Museum of History.)

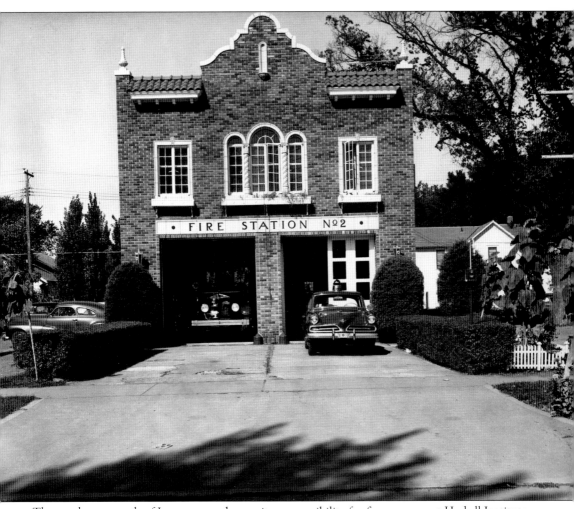

The southern growth of Lawrence and new city responsibility for fire coverage at Haskell Institute required a second fire station at 1839 Mass Street, built in 1928. That station was staffed by three firemen with one pumper truck; the truck is seen in the bay on the left. Opening for the $10,000 building was delayed a month when the fire pole was not delivered on time. Crews at Fire Station No. 1, at Eighth and Vermont Streets, and the new station divided service calls by location north or south of Fifteenth Street. The first call for the crew at Fire Station No. 2 was a grass fire that occurred one week after its opening, December 22, 1928. The two fire stations served all of Lawrence for 40 years until additional growth necessitated two new fire stations in 1968. Fire or ambulance emergency crews used Fire Station No. 2 and its chrome fire pole until 1996. (Courtesy of the Kenneth Spencer Research Library, University of Kansas.)

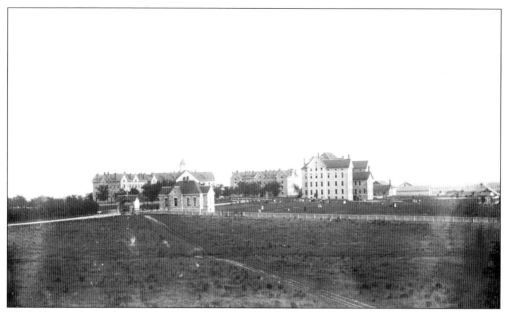

The Indian Industrial Training School was situated on rural land at the southern end of Mass Street in 1884. It used military school techniques to deculturize Native American children, teach them trades, and conform them to White society. The formal entrance at Barker Avenue, dormitories, and farm buildings are seen here. A footpath can be seen going northwest toward Mass Street. (Courtesy of the Kenneth Spencer Research Library, University of Kansas.)

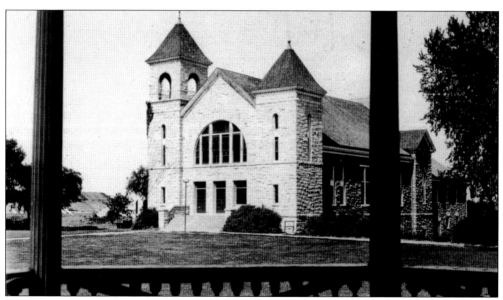

Hiawatha Hall, constructed as a chapel in 1898, is the oldest remaining building on the Haskell campus. After the purpose of the institution changed from forced assimilation to providing secondary education for young adults, the hall was converted for use as an auditorium. The Indian Industrial Training School became Haskell Institute in 1887, renamed for US representative Dudley Haskell. (Courtesy of the Kenneth Spencer Research Library, University of Kansas.)

Four

Essentials

The surfaces, sidewalks, and sewers of Mass Street tell their own version of life in Lawrence through the years.

Flaming lanterns aligned with the North Star marked the first iteration of Mass Street in 1855, drawing the main street of the newborn town in a straight north-south line. River crossings were made possible that fall at the north end of Mass Street using a platform ferry cranked across the river by an attendant using a rope. The first Mass Street bridge supplanted the ferry in December 1863.

Carriage transport across the bridge to the new Union Pacific railroad began in 1864. Mule-drawn streetcars on rails were the next big improvement in 1871, providing extended service south on Mass Street. Then disaster struck in 1903 when flooding washed out the bridge. Although the bridge was immediately rebuilt, the streetcar company remained underwater for another six years until electric cars could be introduced in 1909.

The constantly challenging trifecta of dust, mud, and ice on Mass Street was an ongoing headache for townspeople. Desperate times called for desperate measures, and the situation prompted what turned out to be a very bad idea in 1871. Workers "paved" a portion of Mass Street with wooden blocks. The folly of the effort was soon apparent when the blocks, swollen with moisture and then frozen, heaved unhelpfully out of the ground. By the turn of the 20th century, brick pavers, stone curbs, and gutters stabilized the street surfaces.

By the 1900s, interurban light rail, automobiles, and buses conveniently connected movers and shakers from Lawrence to Kansas City and beyond. Highways opened even broader opportunities. With all the different modes of coming and going, the character of the Mass Street continued to change.

Public utilities evolved as well. During Lawrence's earliest years, drinking water was carried untreated from the river. Hollowed trees caulked with flax rope were the first pipes; as water flowed through, the wood swelled and sealed the pipes. Now, treated water moves through polymer pipes, and stormwater is drained through concrete conduits.

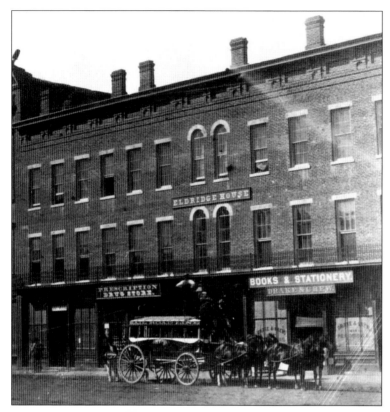

The horse-drawn railroad coach awaits passengers in front of the Eldridge Hotel in the late 1860s. Reconstruction of the hotel after Quantrill's Raid was completed in 1866. Rooms were heated by stoves, requiring multiple chimneys. The newly rebuilt hotel lacked the previous structure's portholes for guns. The coach was replaced by a streetcar line in 1871. (Courtesy of the Kenneth Spencer Research Library, University of Kansas.)

Streetcar rails pass Simpson's Bank (left) at the northwest corner of Eighth and Mass Streets in this photograph from the 1870s. Ramps running from the wooden sidewalks down to the dirt street allowed pedestrians to avoid the mud. The Lawrence National Bank is the building farthest right. (Courtesy of the Kenneth Spencer Research Library, University of Kansas.)

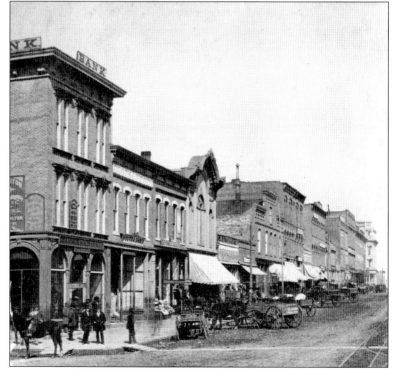

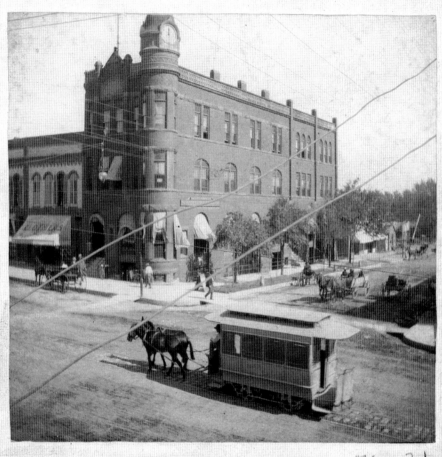

"Progress," the horse-drawn streetcar of the Lawrence Street Railway Company, passes the Merchants National Bank and its clock tower at Eighth and Mass Streets in this 1870s photograph. The streetcar route traversed the wooden Kansas River bridge to reach the Union Pacific depot. Mass Street had wooden sidewalks and dirt streets for another 30 years before brick paving and stone curbs were incorporated beginning in 1899. Hitching posts remained until the early 1900s. Through the course of 40 years, the bridge's wooden structure was gradually replaced by iron. When the flood of 1903 destroyed a segment of the bridge, the Lawrence Street Railway Company went bankrupt, and Mass Street was without a streetcar for six years. When the bank changed ownership in 1930, the clock tower and top floor were removed, and the bank expanded into the storefront to the left. (Courtesy of the Douglas County Historical Society, Watkins Museum of History.)

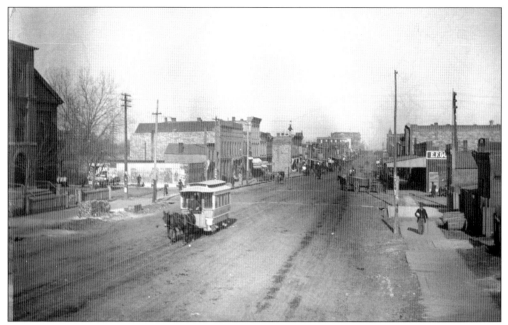

Mules pull the streetcar past the Methodist Episcopal Church at Tenth and Mass Streets. A two-step platform (left) in front of the church allowed congregants to disembark from a carriage more easily. Wooden sidewalks are evident on the right in this photograph from the 1880s. (Courtesy of the Kenneth Spencer Research Library, University of Kansas.)

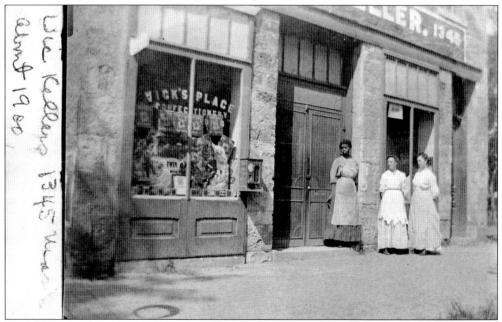

The 1880s commercial building at 1347 Mass Street served as a grocery store and then as a confectionery, shown here in 1900. A streetcar line extension in 1910 and a new high school across the street in 1923 supported a drugstore and an ever-changing parade of restaurants during the 1920s. A vegetarian restaurant, Sister Kettle, had a short run in the 1970s. (Courtesy of the Fitzpatrick-Postma Collection, Lawrence Public Library.)

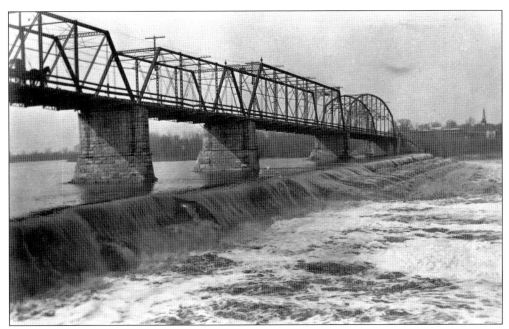

A horse and buggy cross the river bridge in 1903. The fourth span of the bridge, which had an arch design, was destroyed that year by floodwaters that rose to the deck of the bridge. This was the bridge where three Black men were lynched by a mob in 1882. (Courtesy of the Douglas County Historical Society, Watkins Museum of History.)

Flooding on the Kansas River brought crowds to the bridge in 1908. Bicycles were the means of transportation for many people, even in semiformal dress. The stone building was part of the Bowersock Flouring Mills, which was severely damaged during the flood. (Courtesy of the Douglas County Historical Society, Watkins Museum of History.)

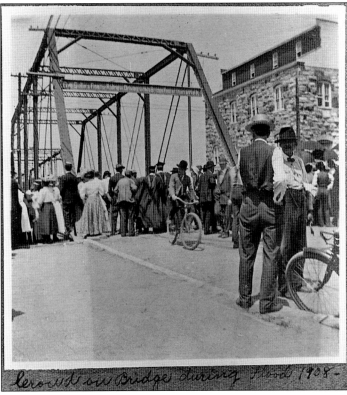

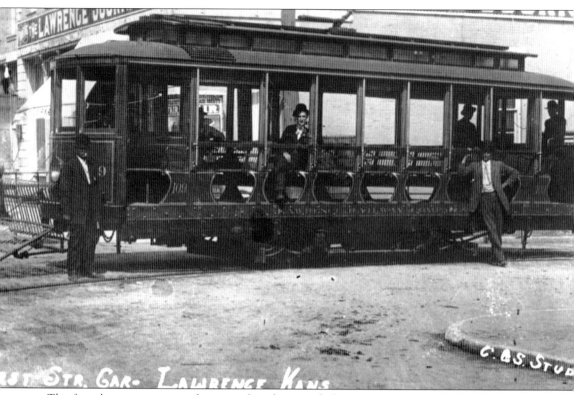

The first electric streetcar is shown in this photograph from 1909. It is on Seventh Street where the east Lawrence branch merged with the Mass Street branch. The street railroad served east Lawrence via Seventh Street to New Jersey Street, south to Thirteenth Street, then east to end up at Woodland Park near Twelfth Street and Haskell Avenue. The Mass Street line was gradually built southward out to Haskell Institute. A university branch went on Eighth Street to Mississippi Street, then climbed Mount Oread. When the river bridge was replaced in 1916, a north Lawrence branch was added to serve the Union Pacific depot. Stone curbs and brick roadway improvements to the north end of Mass Street began in 1899 and worked south as money allowed. The Bowersock Opera House with the first-floor office of the *Lawrence Journal* newspaper is behind the streetcar. (Courtesy of the Kenneth Spencer Research Library, University of Kansas.)

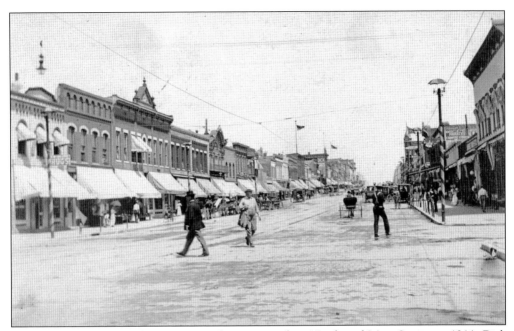

Pedestrians cross the brick pavement and streetcar rails at Ninth and Mass Streets in 1911. Dick Brothers Drug Store at 747 Mass Street is right of center in the photograph; signal flags with weather warnings for the public were flown from the flagpole on top of the building. (Courtesy of the Kenneth Spencer Research Library, University of Kansas.)

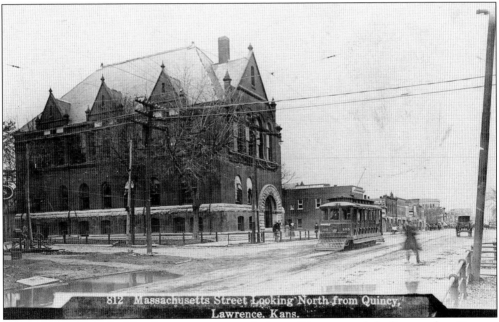

The power and speed of the electric streetcar made it possible to extend the line south to Twenty-third Street in 1910. This stimulated house-building in the rural area next to Haskell Institute, an area marketed as Breezedale. The Mass Street streetcar is shown in front of the Watkins Bank building at Eleventh Street. (Courtesy of the Douglas County Historical Society, Watkins Museum of History.)

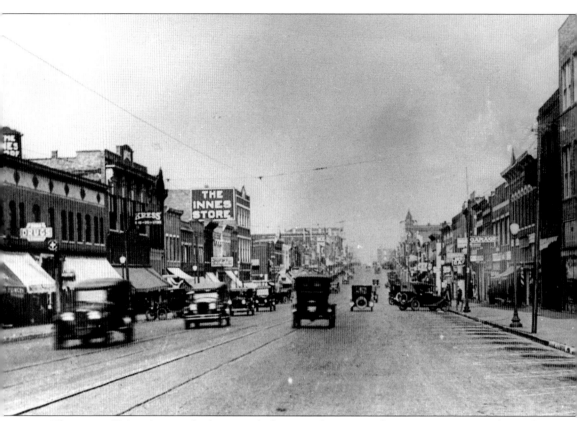

This view of Mass Street is looking north from Tenth Street with a vantage point similar to the photographs on pages 48 and 53. This 1920s photograph shows the effects of the automobile on the streetscape. Lampposts have been added, and the streetcar rails are still present. Within a decade, the Kansas Electric Power Company, which operated the streetcars after 1909, phased in buses to replace them. Ordered, angled parking for automobiles is new, but parking is still free and not limited by meters. The Innes Store at 901 Mass Street is seen left of center. A rooftop tank that was kept full of water for use in case of fire is seen at far left. An automobile repair business is seen on the right. Bigger store signs are intended to capture the attention of potential customers traveling more briskly through an increasingly crowded retail space. (Courtesy of the Douglas County Historical Society, Watkins Museum of History.)

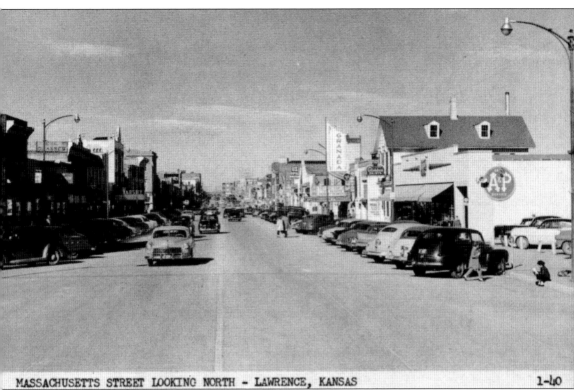

Thirty years later, the view of Mass Street looking north from Eleventh Street shows a thoroughfare with a variety of automobile styles and colors that is a striking change from that of the 1920s. Streetcar rails are gone, and a smooth asphalt surface paves the way. Painted lines delineate traffic lanes. A 20 miles per hour speed limit is in place, and meters encourage the turnover of parking. Lamp poles arch above the street to illuminate the driving lanes. Stoplights and pedestrian crossing signs regulate the interactions of drivers and pedestrians. Weavers is now the store at 901 Mass Street, and the tower of the Merchants National Bank is gone. The A&P supermarket, which brought lower prices and a larger selection to compete with mom-and-pop grocery stores, is on the right. It opened in 1959. (Courtesy of the Kenneth Spencer Research Library, University of Kansas.)

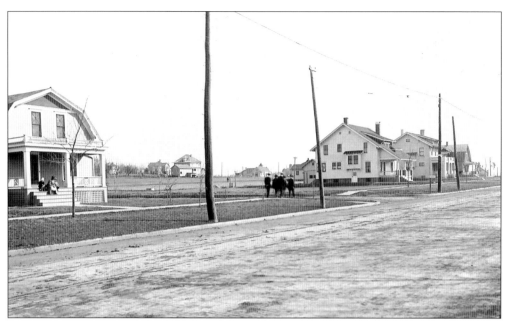

New homes, concrete curbs, and sidewalks line the new brick street in this 1910 photograph of the northeast corner of Twenty-second and Mass Streets, looking to the southeast. At that time, Lawrence was still smaller than Parsons and Pittsburg; only the 11th-largest town in Kansas. (Courtesy of the Fitzpatrick-Postma Collection, Lawrence Public Library.)

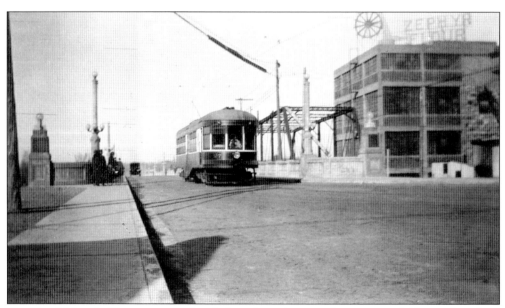

The Kaw Valley & Western interurban light rail ran between Lawrence and Kansas City from 1916 until 1935. Hourly trains left the terminal at 636 Mass Street to cross the concrete Mass Street bridge on the streetcar tracks and merge onto the railroad tracks north of the river. The old metal truss bridge is seen to the right of the railcar. (Courtesy of the Douglas County Historical Society, Watkins Museum of History.)

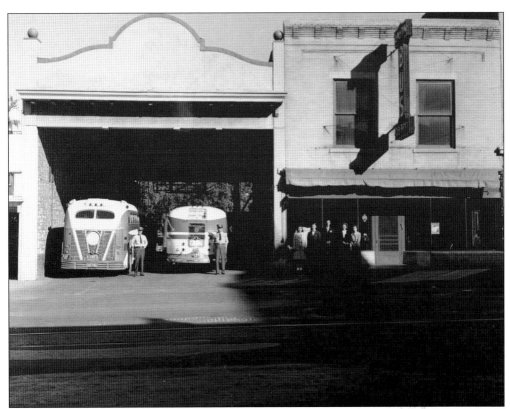

After 1935, motorbus passenger service gradually replaced the interurban. The terminal at 636 Mass Street was repurposed as a bus station, which remained in use until 1982. In 1989, Free State Brewery opened there, the first Kansas brewery after Prohibition. The tiled entry of the ticket lobby at 638 Mass Street still bears the interurban Kaw Valley line logo. (Courtesy of the Kenneth Spencer Research Library, University of Kansas.)

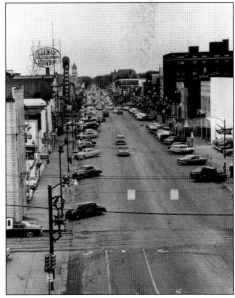

The north end of Mass Street was a busy hub for transportation and services in the 1950s. From left to right are a Mobil Oil gas station, the Santa Fe Railroad spur serving the industrial area, Plymouth/DeSoto Autos, Union Bus depot, the Jayhawker Movie Theater, Kansas Power and Light Service Company, the Eldridge Hotel, Lawrence National Bank, and Chrysler/Plymouth Autos. (Courtesy of the Douglas County Historical Society, Watkins Museum of History.)

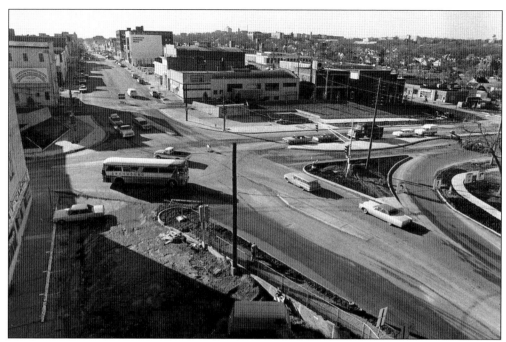

In 1973, the Sixth and Mass Streets intersection and river bridge were rebuilt when the concrete-over-brick road surface used on the single-span bridge built in 1916 began to deteriorate. The bridge was replaced by dual bridge spans over the next seven years. Turning lanes for the Sixth and Mass Streets intersection were added, and a concrete plaza replaced the gas station. (Courtesy of the Kenneth Spencer Research Library, University of Kansas.)

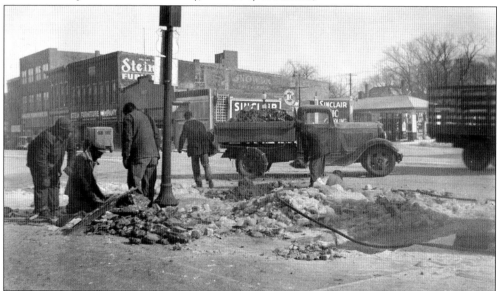

Water mains beneath Mass Street required maintenance during the winter of 1939. The brick pavement had been covered by asphalt. This photograph was taken at the intersection of Tenth and Mass Streets looking northeast. In the background are the Stein Furniture Company (left) in the Eriksen Building at 936–938 Mass Street and the Sinclair Oil gas station (right) at 944–946 Mass Street. (Courtesy of the Douglas County Historical Society, Watkins Museum of History.)

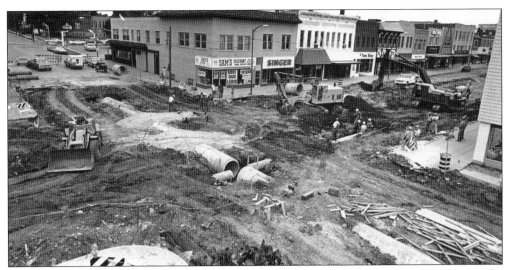

As part of urban renewal in 1972, Mass Street was completely rebuilt. This photograph, taken at the intersection of Ninth and Mass Streets looking northwest, shows the large storm sewers installed under the street. The reconstruction lasted from June until December. Business owners reported no drop in sales. (Courtesy of the Kenneth Spencer Research Library, University of Kansas.)

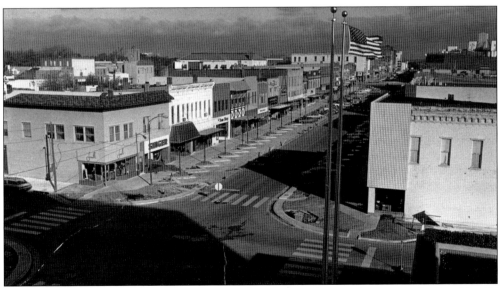

Mass Street got a new look in 1972 with sawtooth parking and an emphasis on pedestrian-friendly amenities. Tree wells, planters with benches, stylish lights over the sidewalks, brick accents, and narrower driving lanes at corner crosswalks made downtown more of a place to linger. Automobile traffic moved more slowly by design. A decorative metal facade covered 846 Mass Street on the right. (Courtesy of the Kenneth Spencer Research Library, University of Kansas.)

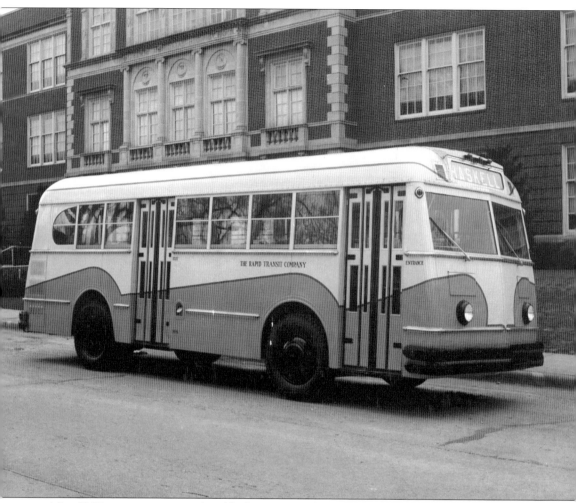

After 1927, streetcars were replaced by buses, A city bus is shown in front of Lawrence Memorial High School in the 1940s. The Lawrence Bus Company operated until 1971, when it ran out of money. The University of Kansas then started its own bus system in 1973. In 2000, the current citywide bus system began; it merged with the university system in 2010. (Courtesy of the Kenneth Spencer Research Library, University of Kansas.)

Five

BUSINESS

Many of the early settlers of Lawrence came here because they wanted to succeed in business, and Mass Street was where they launched their efforts. Most of the businesses stayed afloat for a short time before circumstances changed and they slipped away, forgotten. Capital and credit were hard to come by in Kansas Territory. Suppliers were a long way away. A single drought could wipe out customers' incomes for a year or longer. Store owners needed a highly trafficked location, a keen sense of what the customer might want, enough funds to place a large order for merchandise, and steely nerves to wait for buyers.

Some businesses continued to thrive for many decades, such as the Weaver's department store or the *Journal-World* newspaper. Some, such as blacksmiths or wheelwrights, had to change with the times. Mass Street has always undergirded commerce, but the businesses lining this main street had to adapt, overcome, and, frequently, change locations.

Other enterprises exhibited great innovation, finding new ways to engage their customers and interest new consumers in their products. Barteldes Seed Company sold to farmers and gardeners throughout the West via mail order. Round Corner Drug promoted its health supplements with advertising beginning in the 1870s.

Other stores weathered the years because they evoked memories of days gone by. Nostalgia has certainly played a role at Waxman, where the aroma of burning candles fills the senses. The unchanging displays and the slightly sweet smell of dust, old leather, and a little spilled oil brought customers some sense of comfort in the old Ernst Hardware store until it closed in 2018.

Many of the buildings on Mass Street where these businesspeople did their work remain, though progress in industry and technology has disappeared whole sectors. It is intrinsic to the character of Mass Street that the old and new structures and tenants make interesting neighbors.

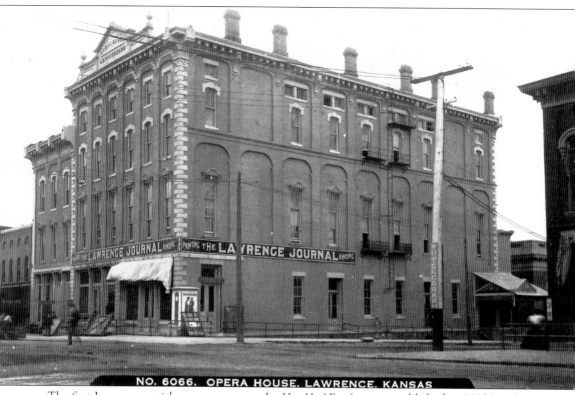

The first Lawrence antislavery newspaper, the *Herald of Freedom*, was published at 646 Mass Street between 1855 and 1860. The paper promoted the views of the New England Emigrant Aid Company and was one of 20-odd newspapers published in Lawrence in the latter half of the 19th century. By 1900, through attrition or consolidation, there were four. The *Lawrence Daily Journal* offices occupied the first floor of the opera house on the same site in this photograph from 1900. The *Journal* traced its lineage back to the *Lawrence Republican*, first published in 1857. It printed an evening four-page edition and a sixteen-page Saturday edition. The newspapers were eight columns wide and carried wire service news from around the world, local information, editorials, train schedules, agricultural market results, legal notices, and advertising. The *Journal* merged with the *Lawrence World*, owned by W.C. Simons, in 1911. It remains the only print newspaper in Lawrence. (Courtesy of the Fitzpatrick-Postma Collection, Lawrence Public Library.)

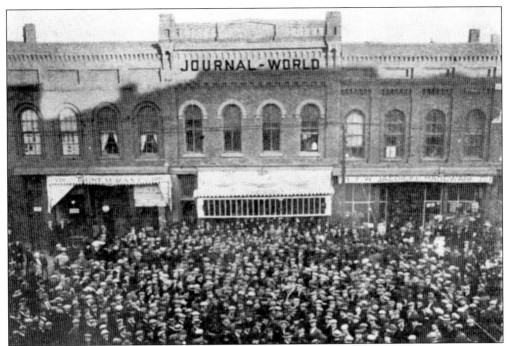

After the opera house burned in 1911, W.C. Simons moved his newspaper to 722 Mass Street. The photograph shows a crowd in front of the *Lawrence Journal-World* building. The fans were in town for the Kansas-Missouri football game on November 24, 1921, held at the newly built Memorial Stadium. (Courtesy of the Douglas County Historical Society, Watkins Museum of History.)

A float in the 1954 Lawrence centennial parade passes the modern facade of the *Lawrence Journal-World* building. The newspaper moved to a newly built office structure at 609 New Hampshire Street a year later and then added a production facility at 608 Mass Street in 1988. The production facility closed in 2014, and the newspaper was sold to Ogden Newspapers in 2016. (Courtesy of the Douglas County Historical Society, Watkins Museum of History.)

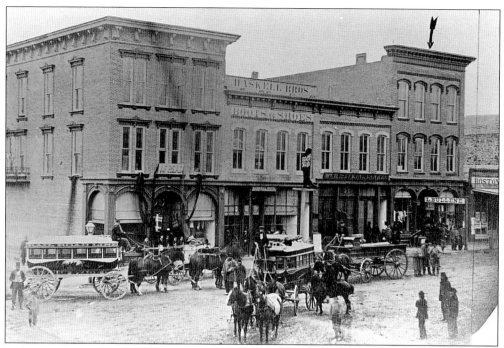

Lathrop Bullene opened a general store on Mass Street in 1857. He sold manufactured goods of the day, including ready-made clothing, fabric, boots, and dry staples such as flour and coffee. He lost everything with Quantrill's Raid in 1863 but rebuilt at 741 Mass Street, shown with an arrow. The building on the left was erected where John Brown was headquartered in 1858. (Courtesy of the Douglas County Historical Society, Watkins Museum of History.)

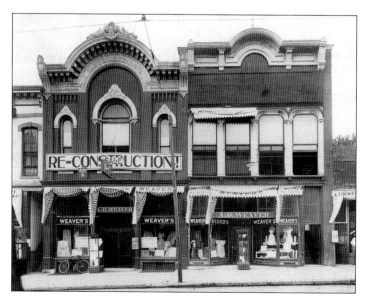

Lathrop Bullene hired A.D. Weaver in 1883, the same year Weaver married Bullene's daughter Gertrude. The "Bullene" name is seen at the top of the building on the left, at 741 Mass Street. Weaver bought the store in 1886, put his name on it, and expanded into 739 Mass Street. A sale that year celebrated the reconstruction of the original store site. (Courtesy of the Douglas County Historical Society, Watkins Museum of History.)

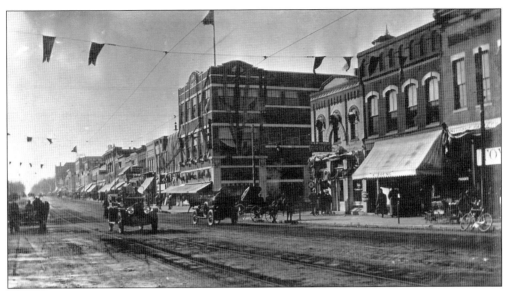

George Innes and his brother started their mercantile store at 901 Mass Street in 1870. Their new building (center) is shown in 1911. George and Eliza Innes' oldest daughter, Janet, married Herbert Bullene, son of Lathrop, and the couple sold the Innes store to their brother-in-law A.D. Weaver in 1929. Weaver added a pneumatic tube system to whoosh payments to a central cashier. (Courtesy of the Fitzpatrick-Postma Collection, Lawrence Public Library.)

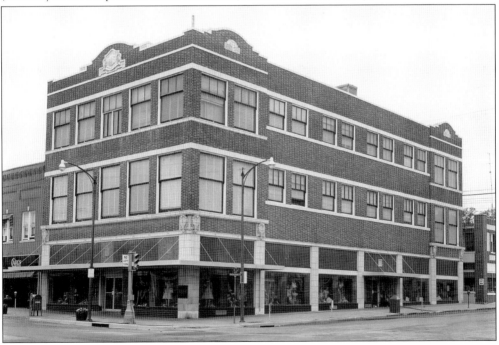

In the 1950s, the Weaver's building still had a crest at the roofline bearing the Innes name. A.D. Weaver's son Art played basketball for the University of Kansas from 1912 until 1914 under W.O. Hamilton and then took over the store. Art sold the store to Larry Flannery in 1950; Flannery acquired the adjacent Carl's Clothiers in 1950. (Courtesy of the Douglas County Historical Society, Watkins Museum of History.)

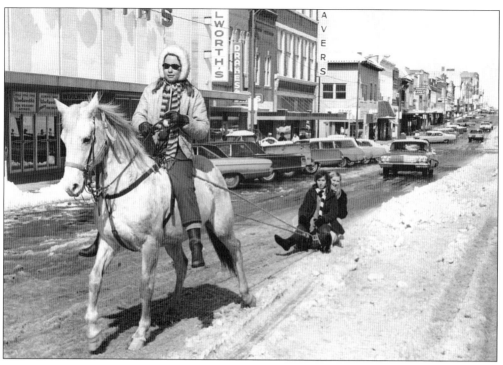

In this photograph from the late 1960s, a modern-day sleigh ride passes the Weaver's building (center) at 901 Mass Street. A few years later, downtown had an entirely different look with a Modernist bank building at 900 Mass Street and a new design for parking, plantings, and lighting. Weaver's got a new facade in 1971 that covered the roofline Innes crest. (Courtesy of the Kenneth Spencer Research Library, University of Kansas.)

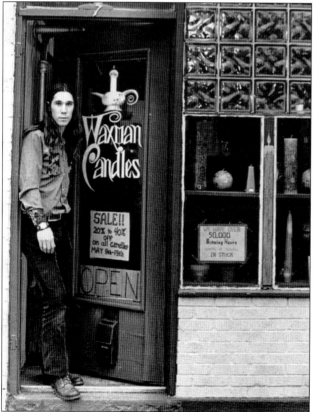

Bob Werts, also known as "Waxman," lived and worked in his first store around the corner from Fourteenth and Mass Streets. He paid $75 per month for the space where he made candles. With his first order, he made no profit but developed his technique. After filling his second large order, he made enough money to move to a storefront at 1405 Mass Street. (Courtesy of Waxman Candles.)

Waxman Candles moved in 1993 to 609 Mass Street (seen above) so Werts could expand the shop's work and display areas and own his own building. This northern reach of Mass Street is seen in the 1911 photograph below showing tornado damage. The businesses from center to right are H. Thompson photography studio, the Harriet Harper barbershop, C.S. Stone restaurant, Junius Underwood seed company (at 609 Mass Street), and Boener Bros. Cigar factory. By 1988, the cigar factory and seed company had been replaced by a gas station and a moving company warehouse, respectively. Waxman's move into the vacant warehouse space came during several decades when industrial buildings on Mass Street were revitalized. (Above, courtesy of Waxman Candles; below, courtesy of the Fitzpatrick-Postma Collection, Lawrence Public Library.)

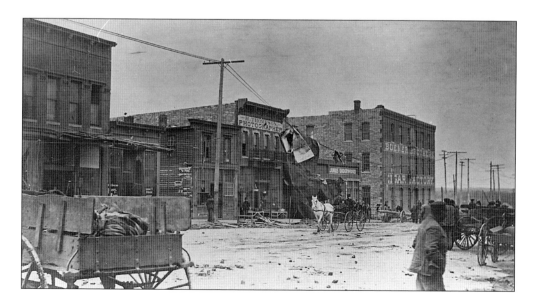

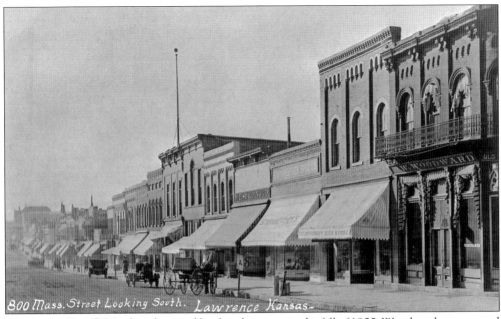

Brinton W. "B.W." Woodward opened his first drugstore in the fall of 1855. Woodward constructed the Round Corner Drug Store building (far right) at 801 Mass Street in 1866 after his first building was burned in Quantrill's Raid and operated it for 31 years. Woodward was the first president of the Lawrence school board and an author and had a large art collection. (Courtesy of the Fitzpatrick-Postma Collection, Lawrence Public Library.)

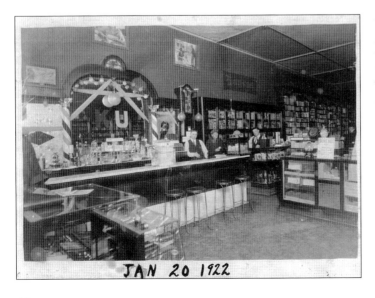

B.W. Woodward was a promoter. His soda fountain was the first thing customers saw when they entered the store and two aisles of merchandise led to the pharmacist's counter in the back. Woodward sold his business in 1897, but Round Corner operated for 154 years, closing in 2009 as the oldest pharmacy in the state. (Courtesy of the Douglas County Historical Society, Watkins Museum of History.)

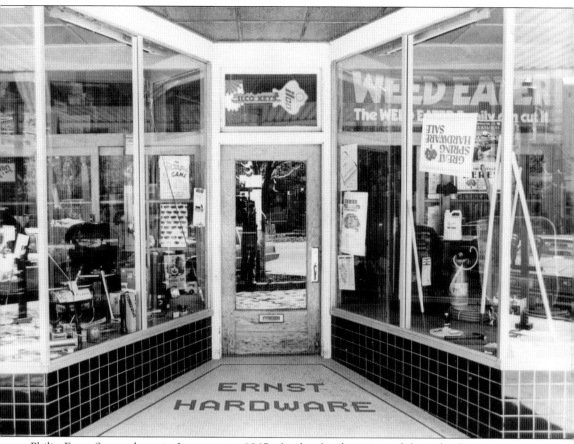

Philip Ernst Sr. was born in Lawrence in 1867 after his family emigrated from the German state of Prussia in 1859. Ernst partnered with Tom Kennedy in 1905 to buy 826 Mass Street from Mary Barnes and open a hardware store. Ernst and his son bought out Kennedy in 1925. (Courtesy of the Douglas County Historical Society, Watkins Museum of History.)

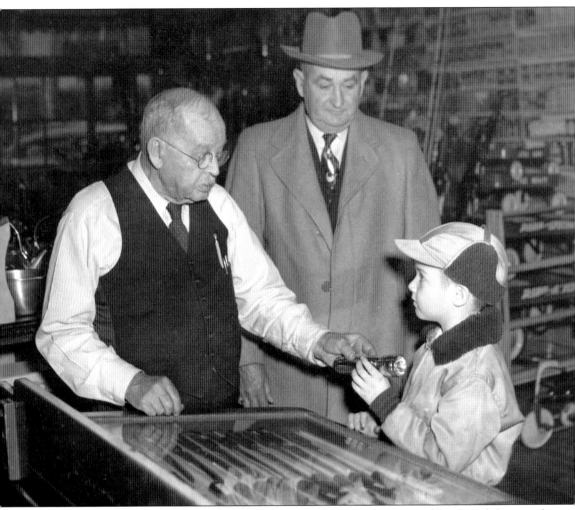

Philip Ernst Sr., left, attends to a customer in his store in 1951. Ernst trod hardwood floors and wheeled the wall ladder for 57 years to access shelves stacked high with nuts, bolts, and buggy whip holders (every era has its gadgets). Ernst's son and grandson totaled purchases on a mechanical cash register another 56 years after their patriarch died in 1962. (Courtesy of the Douglas County Historical Society, Watkins Museum of History.)

Six

DISASTERS

When a city's seal features the immortal phoenix, a mythological bird that repeatedly combusts and rises from its own ashes, it is a clue that disasters are a theme. Beyond the natural catastrophes borne by water, wind, and fire, Lawrence has had to rebuild after violent human-generated ruination both external and internal. Mass Street was the scene of a fictional apocalypse as well, in the film *The Day After* with its grim tale of nuclear cataclysm set in Lawrence.

More than a century before that movie's chilling story of global destruction, the New England Emigrant Aid Company was outfitting its settlers with Sharps rifles, an advanced armament. The first conflagration was May 21, 1856, when a howitzer purloined from the armory in Liberty, Missouri, fired two shots across Mass Street. After both cannonballs missed the Free State Hotel, the timber structure was set ablaze. The next violent incursion to occur on Mass Street was the worst episode of domestic terrorism to that point in American history: Quantrill's Raid on August 21, 1863.

The Kansas River lends its own episodes of chaotic drama to the Mass Street story. Most of the time the river is a welcome friend, slowly flowing with the promise of fresh water, electrical power, and a means of transportation. But when the weather systems of the Central Plains get turned up or turned off, the river flow can vary drastically and wreak havoc. Front page news of a tornado touching down on Mass Street or the tragedy of firefighters facing frostbite and frozen equipment while extinguishing a winter blaze are part and parcel of the history of Mass Street.

With every disaster, business owners have rebuilt. Shalor Eldridge defiantly added a story on the structure when he rebuilt the Free State Hotel. J.D. Bowersock used the destruction of his dam to introduce electricity-generating turbines. Bowersock also rebuilt his opera house after a fire leveled it. Not only was it fireproof, it was strong enough to be deemed bombproof by the US government during World War II. Like high-stakes poker players, people on Mass Street have seen disaster—and raised.

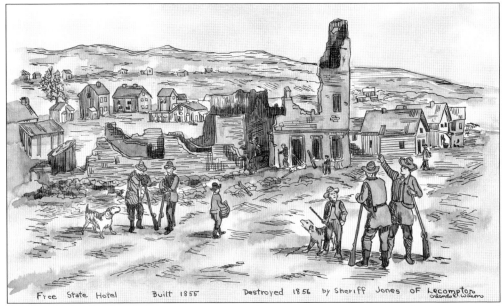

Samuel Lecompte, the proslavery chief justice of the Kansas Territory Supreme Court, summoned militias to Lawrence on May 21, 1856, to back Sheriff Sam Jones as he tried to put down an uprising of antislavery Lawrencians. After two howitzer shots across Mass Street missed the Free State Hotel, Jones burned the hotel and destroyed the press of the *Herald of Freedom* newspaper. (Courtesy of the Kenneth Spencer Research Library, University of Kansas.)

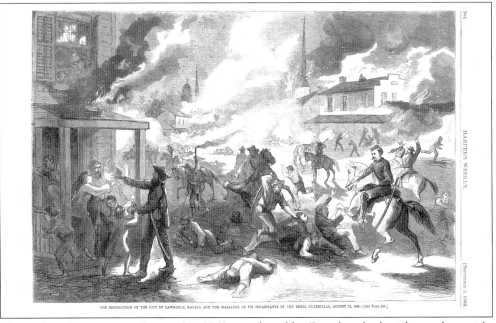

The raid on Lawrence on August 21, 1863, was horrible. Four hundred raiders rode straight up Mass Street then fanned out across 12 blocks east and west. In four hours, they destroyed the second-largest town in Kansas, killing 20 percent of Lawrence's adult men and causing $1.5 million in damage. By noon, only one or two buildings on Mass Street remained. (Courtesy of the Douglas County Historical Society, Watkins Museum of History.)

Massive rainstorms in the Kansas River basin in May 1903 led to flooding. The iron truss bridge and the Douglas County Mill were threatened by the rampaging water. Crowds came to watch the drama unfold. The mill eventually collapsed into the river; one span of the bridge was destroyed, and the powerhouse at the south end had to be rebuilt. (Courtesy of the Douglas County Historical Society, Watkins Museum of History.)

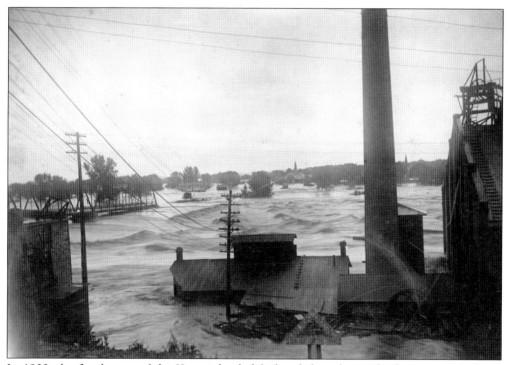

In 1903, the floodwaters of the Kaw violently lifted and then slammed a house into the brick decking and streetcar track of the bridge. Fortunately, only that span was lost, as bridge workers had already separated that segment from the rest of the bridge. The waters inundated the Santa Fe tracks and the barb wire factory for two weeks. (Courtesy of the Douglas County Historical Society, Watkins Museum of History.)

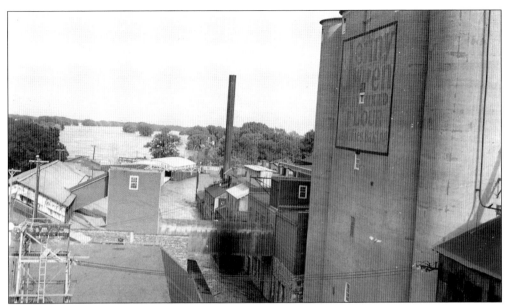

The already rain-soaked ground could not absorb any of the foot of rain that fell on northeast Kansas in mid-July 1951. Consequently, the Kansas River rose 12 feet above flood stage at the Mass Street bridge. The waters flowed into the first-floor windows of the barbed wire factory and covered railroad cars on the Santa Fe tracks. (Courtesy of the Douglas County Historical Society, Watkins Museum of History.)

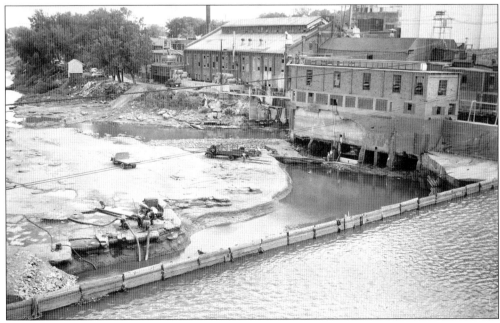

After the flood of 1951, precipitation levels plummeted in 1952 and drought persisted for five years. Although the power production of the Bowersock Dam was diminished, the drop in Kansas River levels exposed the shale bedrock and allowed for maintenance to be performed on the dam and its piers. (Courtesy of the Kenneth Spencer Research Library, University of Kansas.)

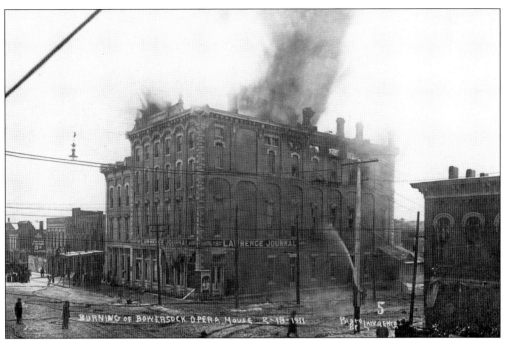

Ironically, electricity from the Bowersock Dam caused the fire that destroyed the Bowersock Opera House on February 8, 1911. The last performance in the hall was by Oscar Wilde. The offices of the *Lawrence Journal* were destroyed as well. The Beaux-Arts structure that replaced it still stands at 644 Mass Street. (Courtesy of the Douglas County Historical Society, Watkins Museum of History.)

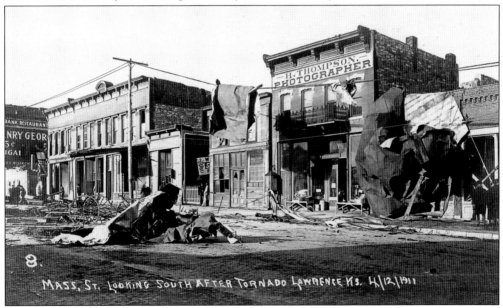

Springtime in Kansas brings the risk of tornadoes, but only one has ever struck Mass Street. The April 12, 1911, twister tore up the Junius Underwood Seed Company at 609 Mass Street, the Shane-Thompson Photo Studio at 615 Mass Street, and the Miller Lumber Company at 627-631 Mass Street. It was the second disaster to strike the north end of Mass Street in 1911. (Courtesy of the Fitzpatrick-Postma Collection, Lawrence Public Library.)

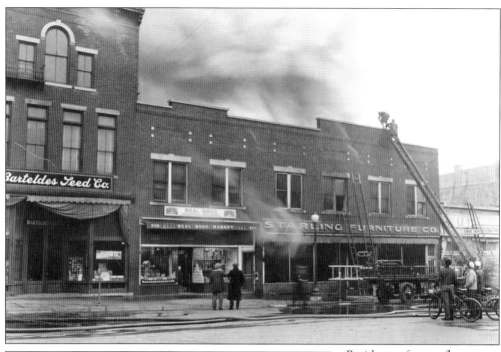

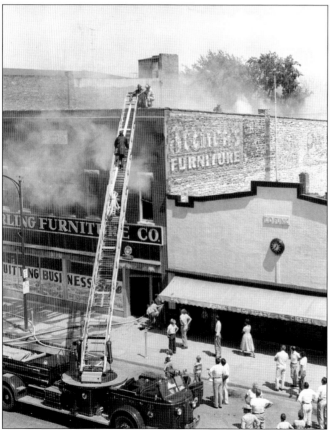

Residents of upper-floor apartments had to rapidly evacuate from a smoky fire that started in the back of the first-floor Starling Furniture store, 808 Mass Street, on March 1, 1945. Jack Byrd, a Lawrence resident, later confessed to starting the fire to spite the owner for denying him credit. (Courtesy of the Kenneth Spencer Research Library, University of Kansas.)

Fire seemed to follow Bernard Firestone, owner of Sterling Furniture. Twice in a decade, his Mass Street furniture stores were burned. Then, on August 24, 1954, his Sterling Furniture store at 938–940 Mass Street caught fire, destroying inventory on the second floor. The building survived. (Courtesy of the Douglas County Historical Society, Watkins Museum of History.)

Clair M. Patee opened the first movie theater west of the Mississippi at 708 Mass Street in 1903. He and Thomas Edison made an early movie projector in 1896. Patee built a new theater at 828 Mass Street in 1913. He died in 1930, and the theater was sold. Firefighters are shown trying to save it from a fire on February 28, 1955. (Courtesy of the Kenneth Spencer Research Library, University of Kansas.)

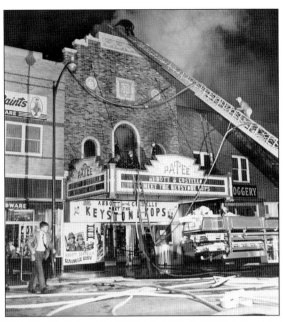

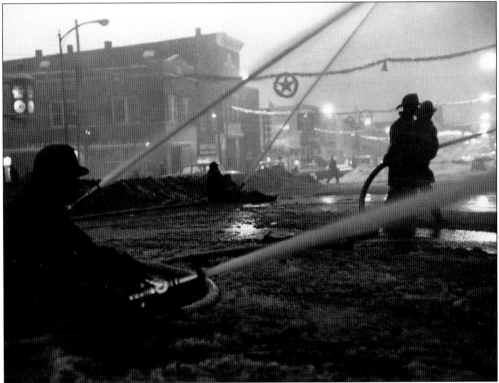

A million-dollar fire started in a laundry across the street from the fire station on December 28, 1966. It consumed three buildings, including 739–741 Mass Street, the home of Miller Furniture. That building originally housed A.D. Weaver's store. Three firefighters were injured fighting the blaze in the 12-degree cold. (Courtesy of the Douglas County Historical Society, Watkins Museum of History.)

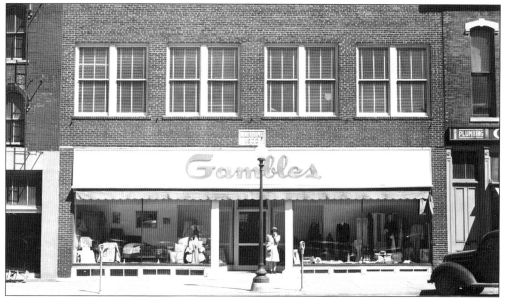

Tensions ran high with protest marches as well as at least 50 reports of arson or snipers in Lawrence during the summer of 1970. A deliberately set fire destroyed the three-story Gambles Furniture building, shown above, at 930–934 Mass Street on the night of April 15, 1970. In the photograph below, bystanders leap onto the ladder truck to create a counterweight after one of the stabilizing jacks failed. The University of Kansas student union and the public school administration buildings were also targeted by arsonists that week. Fire and police crews worked double shifts, and days off were cancelled. Lawrence's mayor asked Gov. Robert Docking to impose a dusk-to-dawn curfew on April 20 that closed all stores and shops and, for three nights, only allowed travel to and from work. (Both, courtesy of the Kenneth Spencer Research Library, University of Kansas.)

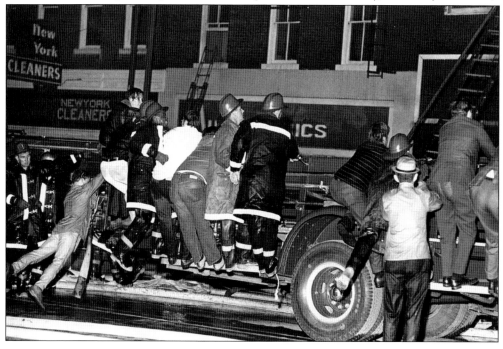

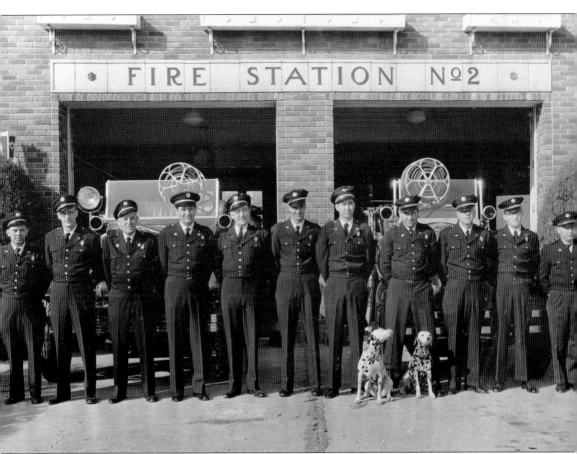

Pictured in 1955 is the crew at Fire Station No. 2. From left to right are C. Cohoon, J. Kasberger, J. Miller (chief), F. Sanders, F. Brown, unidentified, K. Dean, C. Cassidy, L. Spence, L. Burns, B. Freeman, and their dogs Blackie and Sally. Because overnight fire crew staffing was typically 13 men, the multiple large fires on the night of April 20, 1970, required all firefighters to report. The firefighters from Fire Station No. 2 were fired upon at Nineteenth and Tennessee Streets while driving to the public school administration building fire call. Another danger was piano wire strung across alleys with the intent of injuring first responders. Later that night, more than 100 student volunteers helped firefighters fight the blaze that destroyed the University of Kansas student union building. No personnel were injured by the sniper or the conflagrations. (Courtesy of Lawrence-Douglas County Fire Medical.)

Above, the Shrine Bowl parade preceding the football game at Memorial Stadium passes 747 Mass Street, the three-story building at right, on June 11, 1977. Six months later, the building blew up. A natural gas leak caused by a damaged coupling led to a fatal explosion and fire at 1:20 a.m. on December 15, 1977. The tragedy occurred when the owners of the donut shop next door lighted their ovens and the collected gas ignited. The building, which was erected in 1868, was destroyed. The explosion and fire destroyed two buildings on Mass Street and killed two occupants of an upper-floor apartment. Below, firefighters work the fire. (Above, courtesy of the Douglas County Historical Society, Watkins Museum of History; below, courtesy of Lawrence-Douglas County Fire Medical.)

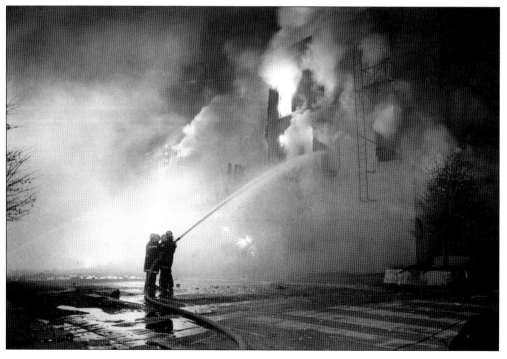

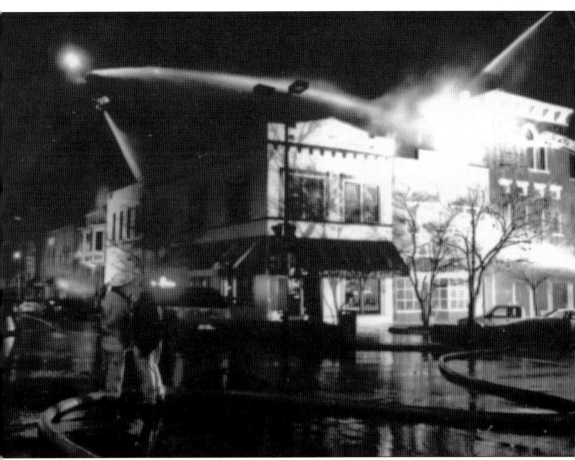

A basement water heater started the million-dollar fire that destroyed the Sunflower Outdoor & Bike Shop at 802–804 Mass Street on February 26, 1997. Firefighters worked hours to keep the flames from spreading to adjacent businesses. The store reopened a year later after a complete reconstruction using timbers and flooring repurposed from old buildings. (Courtesy of Lawrence-Douglas County Fire Medical.)

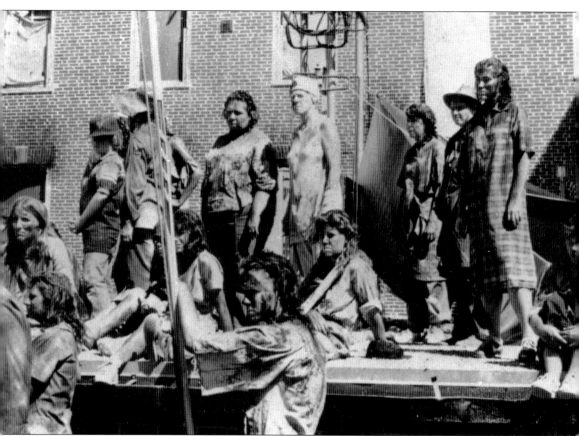

The Day After was filmed in Lawrence and shown on television on November 20, 1983. The film portrayed a fictional disaster featuring the destruction of Mass Street, Lawrence, and possibly the whole earth in a nuclear Armageddon. One hundred million viewers made it the highest-rated television film ever. (Courtesy of the Douglas County Historical Society, Watkins Museum of History.)

Seven

PLACES

Lawrence's civic life was born in 1855 when new settlers put up the Free State Hotel. The hotel at 701 Mass Street gave new transplants their best shot at defensible high ground as well as a roof over their heads while they built their own housing. Nearby meeting halls gave politicos space to argue principles ensuring that Kansas Territory adopted an antislavery constitution.

Institutions of law and order came to Mass Street as well. The 1858 jail and central plaza were by the river bridge where Robinson Park is today. The magnificent courthouse was added at 1100 Mass Street in 1903. City hall has anchored the north end of Mass Street since 1980.

The stage at the Bowersock Opera House (now Liberty Hall) at 644 Mass Street has brought more than a century of good times, ranging from vaudeville to moving pictures to rock and roll. Saloons and pool halls up and down Mass Street have entertained townies from all walks of life. After Quantrill's Raid, the footprint of Mass Street extended south with the First Methodist Church building in 1864. Public band concerts moved from the central plaza to South Park in 1906 when a bandstand was built. Increasingly numerous transportation options allowed Mass Street to continue to grow southward. With the 1923 opening of the Liberty Memorial High School at 1400 Mass Street, Lawrence gained a public auditorium as well as state-of-the-art education facilities.

Even farther south on Mass Street, in 1884, the US government opened the Indian Industrial Training School. The mission of the boarding school was to bring about the cultural assimilation of Native American children by teaching them agricultural, mechanical, and domestic trades. The school became Haskell Institute in 1887 and is now Haskell Indian Nations University. Haskell is the only training school to evolve from imposing non-native culture on native children to embracing the variety of cultures represented on campus and educating Native American leaders of the future. The native-funded football stadium with its distinctive arch served not only Haskell teams, but decades of Lawrence High and then Lawrence Free State High football teams.

This photograph from the 1870s looking down a muddy and rutted Mass Street shows the original Liberty Hall (left), built in 1870. To the right of center is the Eldridge Hotel, and on the right is the National Bank of Lawrence. This intersection of Seventh and Mass Streets was the "sloppy" center of civic life. (Courtesy of the Douglas County Historical Society, Watkins Museum of History.)

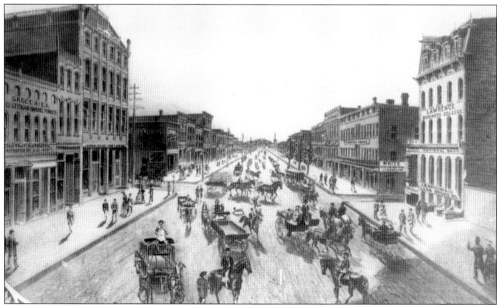

J.D. Bowersock bought Liberty Hall (left) in 1882, added a story to the building, and renamed it the Bowersock Opera House. The Methodist church steeple is in the distance. The Eldridge House and the Victorian-style Lawrence National Bank are on the right. (Courtesy of the Douglas County Historical Society, Watkins Museum of History.)

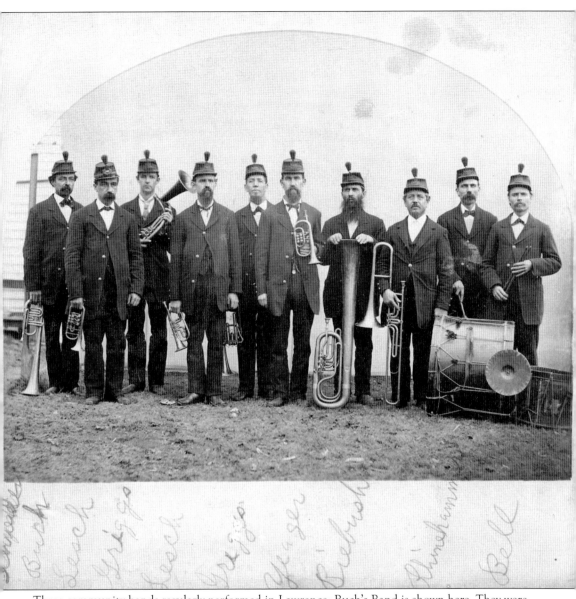

Three community bands regularly performed in Lawrence; Buch's Band is shown here. They were part of the 1859 German social club that met at the Turnhalle building, 900 Rhode Island Street. The band played for Teddy Roosevelt during his carriage ride down Mass Street on May 1, 1903, and marched in the semicentennial parade in 1904. Members built the first South Park bandstand in 1906. The Lawrence City Band originated as a family music group that was on the second New England Emigrant Aid Company journey to Kansas in September 1854. The band held concerts at the plaza by the jail, including, notably, on August 20, 1863, the eve of Quantrill's Raid. Haskell Institute had a nationally known band that featured in many of the Mass Street parades, including a lively one after the Haskell football team trounced Brown, an East Coast football power, on November 8, 1924. Their campus bandstand, now in the National Register of Historic Places, dates back to 1908. (Courtesy of the Kenneth Spencer Research Library, University of Kansas.)

In 1929, to celebrate the 75th anniversary of Lawrence's founding, civic leaders appropriated a 28-ton red quartzite boulder that was venerated by the Kaw Nation. City fathers moved the enormous erratic by rail in the middle of the night and displayed it in Robinson Park with a plaque listing the names of the first settlers of Lawrence. Ninety-five years later, someone thought to ask the Kaw people what their desires were in regard to the rock, which the Kaw called *In Zhuje Waxobe*. The tribe asked that the sacred rock be returned, and in 2023, it was removed from its stone pedestal and transported by truck to the Allegawaho Memorial Heritage Park near Council Grove, Kansas. The plaque is displayed at the Watkins Museum of History. (Above, courtesy Kansas State Historical Society; left, author's collection.)

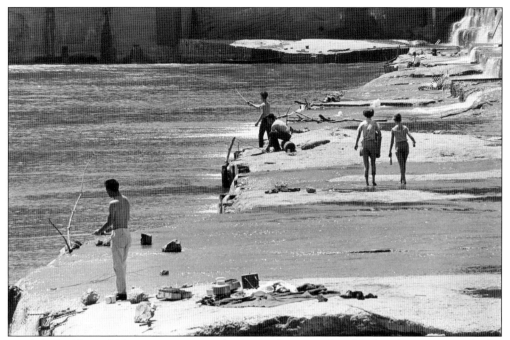

Until the building of Clinton Reservoir in the 1970s, the exposed rock below the Mass Street bridge and Bowersock Dam served as the only natural water recreation site for Lawrence. The "beach" was accessible from the north shore for fishing, boating, sunbathing, and swimming during seasons of low river flows. (Courtesy of the Kenneth Spencer Research Library, University of Kansas.)

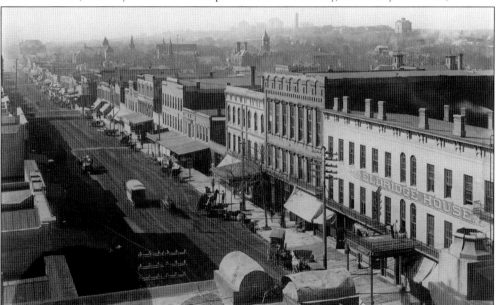

This 1890s view from the roof of the Bowersock Opera House is looking southwest toward the Eldridge House with its multiple chimneys and a growing group of University of Kansas buildings in the distance on Mount Oread. The streetcar on Mass Street and the pole strung with telephone and telegraph wires demonstrate the intracity and intercity connections supporting Lawrence's growth. (Courtesy of the Douglas County Historical Society, Watkins Museum of History.)

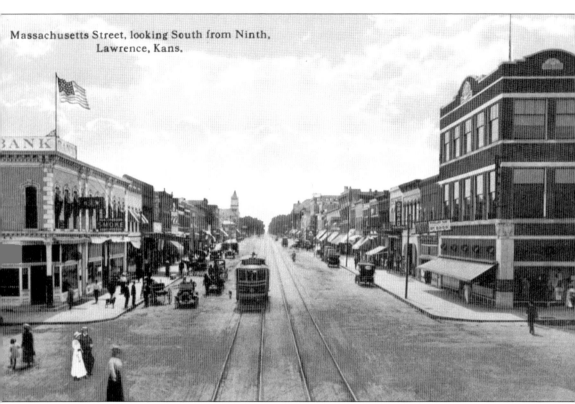

Massachusetts Street, looking South from Ninth, Lawrence, Kans.

Fifty years after Quantrill's Raid, and after a boom in manufacturing, the center of town at Ninth and Mass Streets reflected the prosperity of Lawrence. The State Bank (left) and the new three-story Innes Store (right) dominate the intersection where a variety of conveyances bring people to shop and do business. August Pierson's cigar manufacturing and tobacco wholesaler (second from left) has taken the space occupied by Poehler's wholesale grocery business. Poehler's started as a grocery store and then had a 30-year run as a wholesaler before decamping in 1905 to a large new building by the railroad at Eighth and Delaware Streets. The Oread Theatre at 907 Mass Street (third from right) had only a three-year run, showing movies from 1912 until 1915. A sign in front of the Innes Store promotes the fair at Woodland Park, an amusement park in East Lawrence from 1909 until 1925. (Courtesy of the Douglas County Historical Society, Watkins Museum of History.)

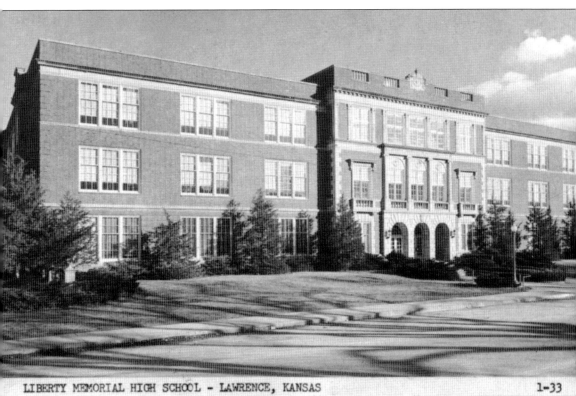

LIBERTY MEMORIAL HIGH SCHOOL - LAWRENCE, KANSAS

Liberty Memorial High was dedicated on September 27, 1923, after a five-year campaign to build a high school commensurate with Lawrence's ambition for its young people. Although Lawrence had only grown six-tenths of a percent a year for the 20 years prior, the old high school was overcrowded and dark. The week prior to the bond issue vote in 1919, a parade down Mass Street featured student-made floats and both military and student marchers. The $600,000 building incorporated new technology with telephones in each classroom connected to a central switchboard, removable interior walls, and forced air ventilation. The new school was located south on Mass Street, halfway between the business district and the new housing at Twenty-third Street. Its 1,050-seat auditorium was the largest in the state, suitable for student or public performances. The building served as a monument honoring the soldiers of World War I. During its long stint as the only high school, the school mascot, the Chesty Lion, was adopted in 1946. (Courtesy of the Kenneth Spencer Research Library, University of Kansas.)

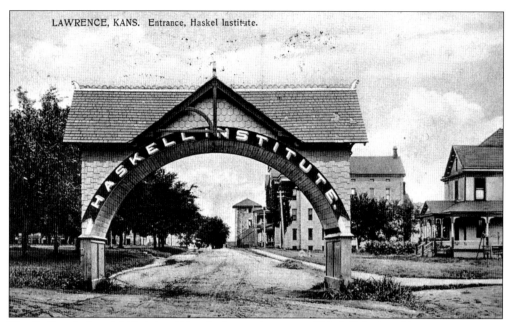

The Indian Industrial Training School, the predecessor of Haskell Indian Nations University, opened in 1884 on land at the far south end of Mass Street. The Barker Street entrance to the roughly 400-acre farm is shown. The training school housed 22 Native American children ages 6 to 10. Boys were taught farming and related trades; girls were taught domestic skills. (Courtesy of the Kenneth Spencer Research Library, University of Kansas.)

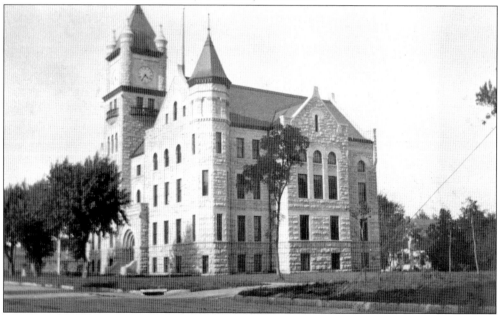

The new Douglas County Courthouse, designed by Lawrence's own J.G. Haskell, was completed in 1903. It features Cottonwood limestone from Chase County and decorative motifs inspired by the Watkins Bank Building at the same intersection of Eleventh and Mass Streets. Dirt streets were paved by that time, but there was not a streetcar line that far south until 1909. (Courtesy of the Douglas County Historical Society, Watkins Museum of History.)

The Watkins Bank Building, constructed in 1888, was the center of J.B. Watkins's land, mortgage, and banking business. Marble floors and wainscoting were intended to impress investors and allow easy cleanup of the street dust. Watkins's widow, Elizabeth, donated the building to the City of Lawrence in 1929, at which time it became city hall. (Courtesy of the Douglas County Historical Society, Watkins Museum of History.)

In 1971, Lawrence city offices were removed from the Watkins Bank Building, and the old structure became the new home of the Watkins Museum of History and the Douglas County Historical Society. The empty lot adjacent to the building was transformed into the Japanese Friendship Garden in 2000. It commemorates the sister city relationship between Lawrence and Hiratsuka, Japan. (Courtesy of the Kenneth Spencer Research Library, University of Kansas.)

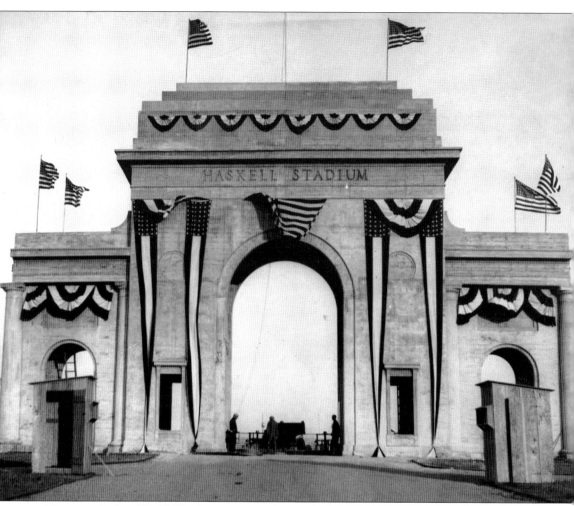

The nation's first World War I monument, the stately arch at the entrance of Haskell Institute's football stadium, was dedicated on October 30, 1926. The lead donors, Haskell alumnae Agnes Quapaw and Alice Beaver Hallam, honored tribal members' service in the war. The same week, an intertribal powwow at Haskell drew 5,000 native people from as far away as Montana to camp on a 40-acre site on the school grounds near the south end of Mass Street. They celebrated with fancy dance contests, cooked bison in the traditional way, and hosted tens of thousands of visitors. The storied Haskell football team throttled Bucknell 36-0 at the new stadium, the only lighted football field in Kansas. The complex was largely funded by native people, largely from the Osage and Quapaw tribes who had wealth from oil and mineral leases. Their interest in supporting this effort grew out of two football team victories in December 1924: a public contest against Oklahoma Baptist and a secret one versus the professional Kansas City Cowboys. (Courtesy of the Kenneth Spencer Research Library, University of Kansas.)

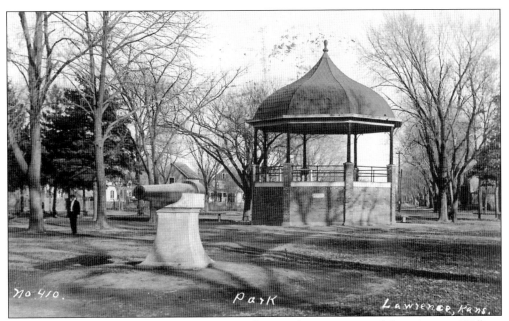

South Park, which straddles Mass Street, initially served as a communal farming area. William Quantrill gave his mounted band of 400 men final instructions here at dawn on August 21, 1863, before their assault. The first South Park bandstand was built in 1906 by German members of Buch's Band. The picturesque structure has been the site of summer band concerts ever since. (Courtesy of the Fitzpatrick-Postma Collection, Lawrence Public Library.)

Art in the Park has graced South Park annually since the mid-1960s. Pictured with art patrons is a watercolor of the park's bandstand and the 10-ton drinking fountain for horses, originally installed in the Ninth and New Hampshire Streets intersection and dedicated in 1910 by Teddy Roosevelt. It was relocated to Robinson Park in 1929 and South Park in 1965. (Courtesy of the Kenneth Spencer Research Library, University of Kansas.)

The Douglas County picking and fiddling contest began in 1976 as part of the Lawrence bicentennial celebration. Since 1981, the event has served as the Kansas State Championship for all ages of pickers and fiddlers. Impromptu jam sessions and formal stage presentations unfold in South Park annually during the fourth weekend in August. (Courtesy of the Kenneth Spencer Research Library, University of Kansas.)

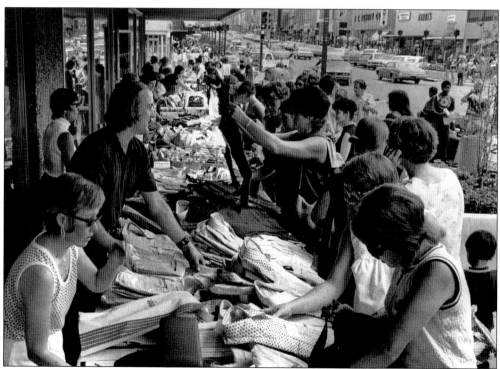

Since 1960, bargain hunters have flocked to Mass Street on a designated day in July for the downtown merchants' summer sale. For the first 60 years, wares were displayed on the sidewalks throughout the day, daring shoppers and employees to defy the combo plate of heat and humidity. Beginning in 2023, the event is planned for a more reliably comfortable June evening. (Courtesy of the Kenneth Spencer Research Library, University of Kansas.)

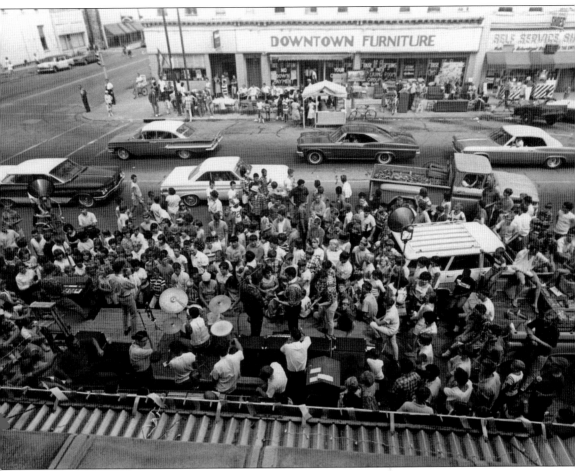

The 1966 summer sidewalk sale attracted young shoppers to Ninth and Mass Streets with a six-man rock band on a platform in front of Weaver's department store. The crowd spilled into the street below the bank of speakers. Merchants marked down their excess inventory to clear the shelves for fall shopping. (Courtesy of the Kenneth Spencer Research Library, University of Kansas.)

Headquarters was founded in 1969 as a commune dedicated to helping youth safely navigate the drug culture. The organization moved to this house at 1602 Mass Street in 1970 and began offering free testing of street drugs to detect potentially lethal contamination. Kansas attorney general Vern Miller closed the drug-testing operation in 1973; the organization survives today as a suicide prevention agency. (Courtesy, author's collection.)

Eight

PEOPLE

Any attempt to compose a hall of fame list of individuals representing Mass Street falls woefully short. Who came? Who stayed? Who put their mark on Mass Street and this part of the world? Some of those listed here were in the right place at the right time, lucky-dog beneficiaries of fortuitous timing. Others enjoyed the silver spoon early on, with a head start from an excellent education or family wealth. And then there were those who just refused to give up, ones blessed with an extra dose of tenacity or special talent.

Mass Street resident James Naismith expressed his hope for a legacy in simple words that many would echo. The inventor of basketball said he only wanted "to leave the world a better place for my having been here." Although the list that follows is hardly all-inclusive, each of these heroes of Mass Street made their own lasting improvements along the way.

John Gideon Haskell's father came to Lawrence in 1854 with the New England Emigrant Aid Company. When Haskell's father was dying three years later, he sent for his eldest son, John, to come to take care of the family. Haskell had completed his education at Brown University and was working for an architectural firm in Boston. In Lawrence, he immediately went to work on the design of the Free State Hotel rebuild in 1857 and the new city jail at Sixth and Mass Streets in 1858. After a nearly 50-year prodigious career designing buildings at the University of Kansas, Kansas churches and courthouses, and the east wing of the state capitol building, Haskell helped design the Douglas County Courthouse in the Richardsonian Romanesque Revival style. (Courtesy of the Kenneth Spencer Research Library, University of Kansas.)

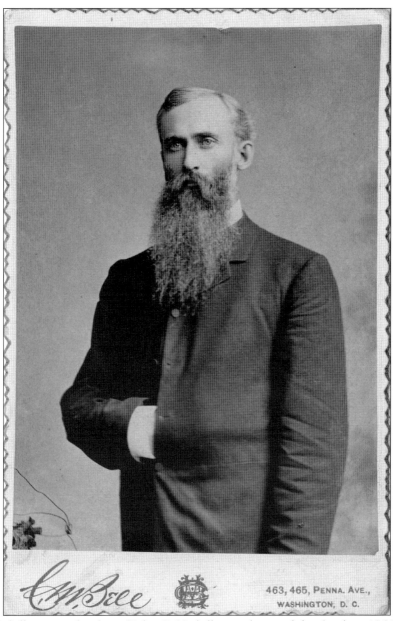

Dudley Haskell, younger brother of John G. Haskell, came here with his family in 1854 at age 13. He was educated in Vermont and then tried his hand in the Pikes Peak gold rush from 1859 until 1861. Haskell served in the Union army from 1861 until 1862 and then went to seminary and college, obtaining a degree from Yale University in 1865. He then pursued business interests in Lawrence, including a boot store at 745 Mass Street near Lathrop Bullene's store and a partnership with George Terry, the first husband of Mary Barnes (see page 27). His political career began in 1872 when he was elected to the Kansas House of Representatives and culminated in his election to the US House of Representatives, where he served four terms. He was chair of the Committee on Indian Affairs and used his influence to bring the Indian Industrial Training School to Lawrence. Haskell died in 1883, and in 1887, the school was renamed in his honor. (Courtesy of the Kenneth Spencer Research Library, University of Kansas.)

Sara Robinson was classically educated at the New Salem Academy in Massachusetts. She was firmly in the abolitionist camp when she came to Lawrence with her husband, Charles, in 1855. A year later, she published *Kansas: Its Interior and Exterior Life*. Robinson wrote a compelling description of Lawrence: "A little hamlet upon the prairie, whose fame has even now crossed the continent, awakening hopes and fears, in the hearts of many, for friends who for six months have battled with pioneer life. Malignity and hatred have been aroused in the souls of others, who see in this little gathering of dwellings of wood, thatch, and mud hovels, the promise of a new state, glorious in its future." Readers in Robinson's day considered the book second only to *Uncle Tom's Cabin* as an influential abolitionist work. Sara Robinson lived until 1911; she and her husband gave their land and money to establish the campus of the University of Kansas. (Courtesy of the Kenneth Spencer Research Library, University of Kansas.)

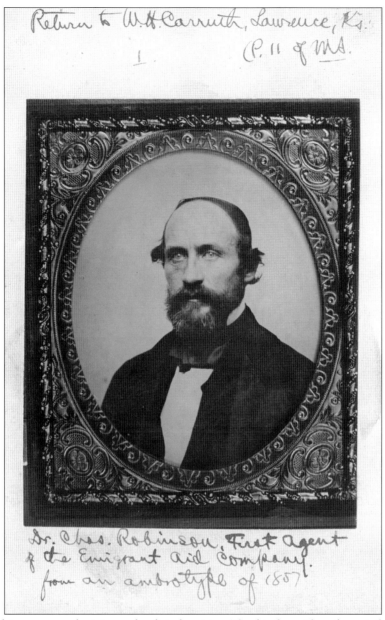

Charles Robinson was a physician and political activist. After his first wife and two infant children died, he left his home state of Massachusetts in 1849 to follow the Oregon Trail through Kansas Territory to the California gold fields. There he practiced medicine and was elected to the state legislature. He returned to Massachusetts in 1851 and married Sara, a fellow abolitionist. Robinson was instrumental in choosing the site for Lawrence next to the Oregon Trail and headed the second group of settlers sponsored by the New England Emigrant Aid Company in September 1854. Charles and Sara had a home on Mount Oread that was burned during the first sack of Lawrence in 1856. Both he and Sara remained active in efforts to bring Kansas into the Union as a free state. He was the first governor of the new state of Kansas in 1861 and served one term. He also was a member of the Kansas Board of Regents and superintendent of Haskell Institute after his political career ended. (Courtesy of the Kenneth Spencer Research Library, University of Kansas.)

Shalor Eldridge is pictured in 1854 with his first wife and four daughters; from left to right are Josephine, Shalor, Eva, Mary Sophia, wife Mary, and Alice. The family came to Lawrence the next year. Eldridge escorted a contingent of antislavery settlers from Iowa along with a cache of cutting-edge Sharps rifles. Shalor Eldridge built hotels; his brothers Tom and Ed financed and operated them in Kansas City, Lawrence, and Coffeyville. They bought the Free State Hotel and had to rebuild it twice after proslavery contingents torched it. Eldridge was influential politically and frequently was on the front line in discussions with the governor or with confrontations with proslavery ruffians. During the Civil War, he served as a lieutenant with the 2nd Kansas Infantry. He was the contractor for the original Fraser Hall at the University of Kansas, built in 1872. (Courtesy of the Kansas State Historical Society.)

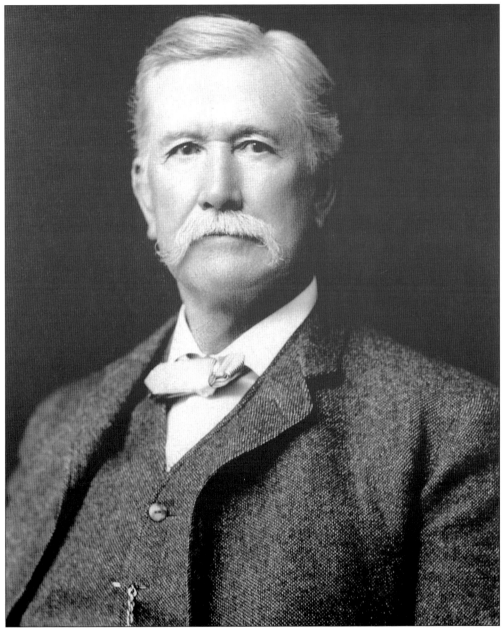
Lathrop Bullene emigrated from New York to establish his mercantile business in a frame building near Eighth and Mass Streets in 1857. He was out of town on the day of Quantrill's Raid, and his wife, Susan, saved their home by telling the raiders her ill mother was inside. Their store, however, was burned with a loss of $20,000 in merchandise. Bullene rebuilt with the extensive assistance of creditors. The new store at 741 Mass Street burned in 1873, and Bullene again rebuilt. He hired his son-in-law A.D. Weaver in 1883, then sold the business to him and retired in 1886. Bullene and his brother also operated a store in Kansas City. Bullene was active in civic affairs, serving on the committee organizing the semicentennial celebration of 1904. In retirement, he and Susan lived at a country estate near present-day Nineteenth Street and Haskell Avenue. Bullene passed away in 1915. (Courtesy of the Kenneth Spencer Research Library, University of Kansas.)

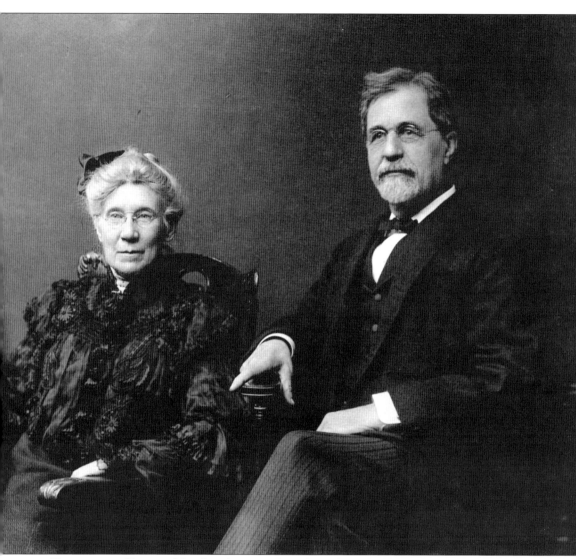

This portrait of Peter and Sarah Ridenour is from the early 1900s. Peter and his friend, brother-in-law, and business partner Harlow Baker opened their first grocery store at 646 Mass Street in 1858. They moved the business to 804 Mass Street in 1860. On August 21, 1863, Quantrill's raiders burned down the building and all the inventory Ridenour had just purchased in New York. Baker was shot in the neck by the raiders and severely wounded. The Ridenours' house was destroyed. The next Monday, Ridenour was back in business, selling goods from a corn crib on top of the rubble. Retailers in Leavenworth gave him merchandise on credit. Peter Ridenour managed all the business affairs and encouraged his friend's recovery. Baker resumed work months later. Ridenour and Baker rebuilt and grew their business. In 1878, they expanded and opened a grocery wholesale warehouse in the West Bottoms of Kansas City, Missouri, adjacent to a railroad hub. It became the leading grocery wholesaler in Kansas City. (Courtesy of the Kenneth Spencer Research Library, University of Kansas.)

John Lewis Waller and his family were freed from slavery in 1862 when John was 11. The family eked out a living on a farm in Iowa, and Waller went to school for the first time. His interest was in law and politics, and through the assistance of a local attorney, he taught himself law and passed the bar. In 1879, he and his wife moved to Lawrence to pursue business and political opportunities. His law office was at 832 Mass Street. He served on the Lawrence school board and helped bring peace to the community in the aftermath of the lynchings of 1882. Waller sought more opportunities for Blacks in society and used his political skills to that end. He was an elector from Kansas in the presidential election of 1888 and voted for Benjamin Harrison. In 1891, Harrison appointed him US consul to Madagascar. That foreign service ended in 1895 when the French invaded, accused Waller of treason, and took him back to France in chains. Vigorous diplomacy eventually freed him. (Courtesy of the Kansas State Historical Society.)

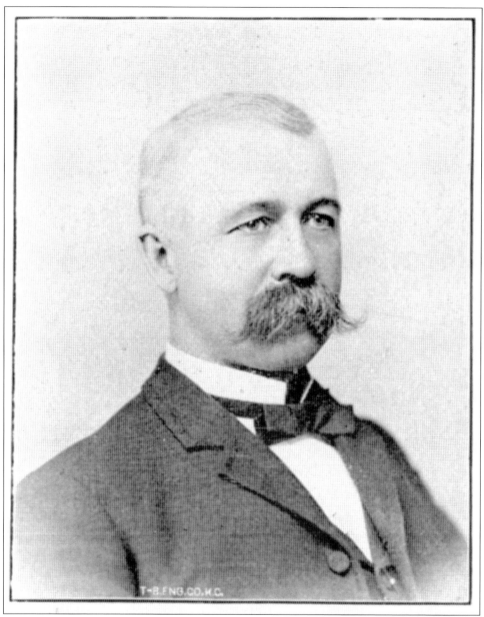

Albert Henley was a self-taught genius in mechanical engineering and invented machines that could stretch, galvanize, and then wind and cut three strands of steel wire into barbed wire. He and his wife, Eleanor, settled in Lawrence in 1878 and opened their barbed wire factory. It was situated on the river to take advantage of the power-generating dam and the Santa Fe Railroad line. With Henley's machines and the almost unlimited market for fencing in the lands to the west, the Consolidated Barbed Wire Company became the largest in the country. The company constructed a new building in 1891 that still stands by the river at 8 East Sixth Street. In 1899, Consolidated's steel supplier, American Steel Company, demanded control of Henley's manufacturing colossus. When he refused, American Steel cut off Henley's supply, and he was forced to sell. He then started a new business, headquartered at 700 Mass Street, using Kansas limestone and sand to make plaster. (Courtesy of the Douglas County Historical Society, Watkins Museum of History.)

Eleanor Henley lived out the principles of her Quaker upbringing by working to better her community. She saw the broken-down ruins of the old jail at Sixth and Mass Streets and envisioned a park to replace them. Henley tied this to the 75th anniversary of the founding of Lawrence, and Robinson Park was born. She was a self-trained architect who designed her own home; her church, the First Presbyterian Church at Ninth and Vermont Streets; and the children's reading room of the Carnegie Library across the street. Not one to simply lead the library's building and grounds committee, she personally trimmed the chestnut and cypress trees that continue to grace the lawn of the Carnegie building. She adopted technology such as the electric car early on and used it to give weary students rides up the hills to the University of Kansas. Her last gift to the community was a house near campus that she gave to the YWCA for use as integrated women's housing in 1945. (Courtesy of the Douglas County Historical Society, Watkins Museum of History.)

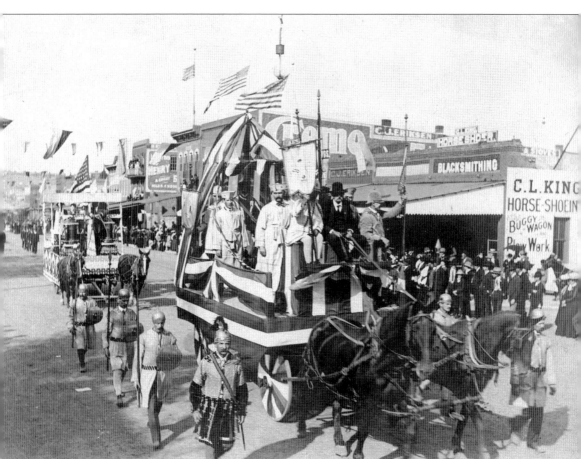

Prussian Germans were immigrants to Lawrence in the first 10 years of the town's existence. They left Prussia after their revolt against monarchical rule failed. Many of them had skills or money or both, so they opened main street businesses. Store signs for Menger Shoes, Wiedemann Confectionery, Ernst Hardware, Achning Hardware, and Bromelsick Hattery announced their success on Mass Street. This picture shows a float celebrating German culture in the 1904 semicentennial parade. The German society was centered on the Turnhalle. It had its greatest membership in the 1880s then faded in importance as the younger generation blended into the greater Lawrence community. A sharp downturn occurred in World War I when anti-German sentiment grew exponentially in Lawrence as elsewhere. Germans had to defend their loyalty to the United States, and non-naturalized Germans were forced to register as alien enemies. (Courtesy of the Douglas County Historical Society, Watkins Museum of History.)

After James Naismith retired and Phog Allen finished his playing career and went to medical school, W.O. Hamilton coached the University of Kansas basketball team from 1909 until 1919. He pioneered frequent substituting to keep his players fresh. Hamilton turned the reins over to Phog Allen in 1919 and opened a Chevrolet auto dealership at 1028 Mass Street. (Courtesy of the Kenneth Spencer Research Library, University of Kansas.)

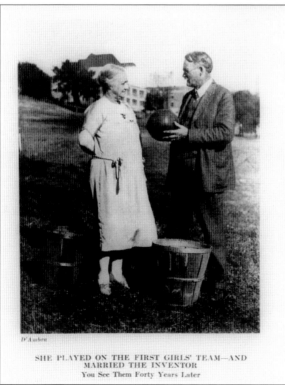

SHE PLAYED ON THE FIRST GIRLS' TEAM—AND MARRIED THE INVENTOR
You See Them Forty Years Later

James and Maude Naismith moved to 1635 Mass Street in 1907 when he stopped coaching. James never profited from inventing the game of basketball, so his family of seven lived on his professor's salary. He was a troop chaplain in France from 1917 until 1919. They lost the house to foreclosure in 1923, and James built their next home himself. (Courtesy of the Douglas County Historical Society, Watkins Museum of History.)

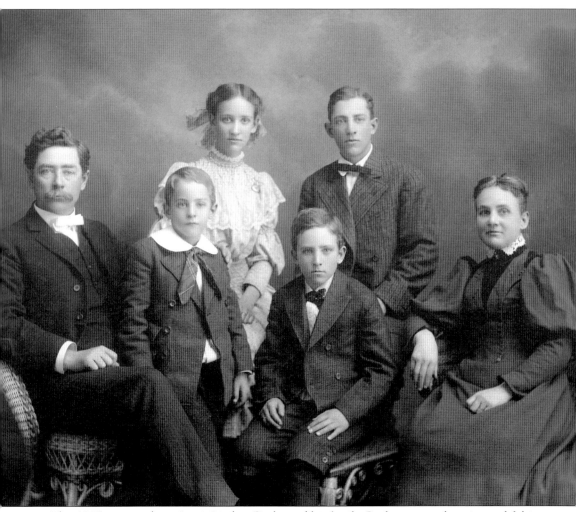

This 1905 portrait shows Lewis Lindsay Dyche and his family. Dyche grew up hunting and fishing near Overbrook, Kansas. He parlayed these skills into collecting specimens of birds and mammals and was a professor and curator of animals and birds at the University of Kansas from 1889 until 1909. His assembled panoramas of posed animals attracted record crowds to the Kansas exhibit at the 1893 World's Columbian Exposition in Chicago. Dyche sailed to northern Greenland in 1895 to gather more specimens and on that trip was credited with rescuing Lt. Robert Peary, who was stranded trying to reach the North Pole. Dyche was named Kansas Fish and Game warden in 1909 and stalked Topeka bureaucrats for the rest of his career. He and his wife, Ophelia, purchased their dream home at 1617 Mass Street in 1914. It was two doors up from the Naismiths' home. Legend has it that Dyche often preferred to sleep in a tent in the backyard rather than roughing it inside. Dyche died of heart failure in 1915. (Courtesy of the Douglas County Historical Society, Watkins Museum of History.)

Leo Beuereman lived on a farm eight miles south of town. He had poor vision that was only partially corrected with glasses, was nearly deaf, and had shortened limbs that made it impossible to walk. With cleverness and determination, however, he worked out a way to make a living. He built a small cart in which he could propel himself, then rigged up a rope-and-pulley system to lift himself and his cart up onto a tractor. Every morning he would chug downtown on his tractor and deploy his cart so he could sell pens and pencils. Centron Films of Lawrence produced an 11-minute feature based on his autobiography that received an Academy Award nomination in 1969. He stopped driving shortly thereafter, at the age of 67, but continued to work, selling mail-order magazine subscriptions from his home. A plaque honoring Beuereman is at his sales site, the northeast corner of Eighth and Mass Streets. (Courtesy of the Douglas County Historical Society, Watkins Museum of History.)

Elizabeth Watkins is shown here in later life at her desk with a picture of her husband, J.B. Watkins. Watkins moved to Lawrence in 1872 at age 11, and four years later, she started working at the Watkins Land and Mortgage Company, 1047 Mass Street. During a 30-year career, she learned the mortgage business and managed public relations for the firm. She became J.B. Watkins's trusted personal secretary and that is probably when their relationship turned romantic. When she was 48, they married. J.B. died 12 years later, leaving his substantial fortune solely to Elizabeth. She gave the magnificent Watkins building to the city for use as city hall, and it is now the home of the Watkins Museum—so the stories of history can always be told on Mass Street. She gave their home to the University of Kansas for the chancellor's residence and endowed two scholarship halls as well as the student health hospital at the university. (Courtesy of the Kenneth Spencer Research Library, University of Kansas.)

John Levi was an Arapaho athlete talented in football, track, and baseball who lifted Haskell football to its apogee between 1921 and 1924. Jim Thorpe called him "the greatest athlete I have ever seen." With Levi, Haskell football beat powerhouses such as Baylor and Brown. In a promotional first-ever football game at Yankee Stadium in November 1923, Haskell tied the Quantico Marines, and Levi signed a Yankees contract after the game. Levi was considered a shoo-in for the 1924 Olympic team in the decathlon, but his professional contract precluded it. Levi's final football game was a secret game on a makeshift field in the Osage Hills near Pawhuska, Oklahoma. It pitted the Haskell Indians against the professional Kansas City Cowboys. Levi and the Indians prevailed 13 to 12. This was the game depicted in the 2023 film *Killers of the Flower Moon*. With the 1924 football success, Haskell pushed for a new 10,500-seat lighted stadium. They had great success raising funds from the Osage people, whose reservation land controlled the oil leases in Oklahoma. (Courtesy of the Kenneth Spencer Research Library, University of Kansas.)

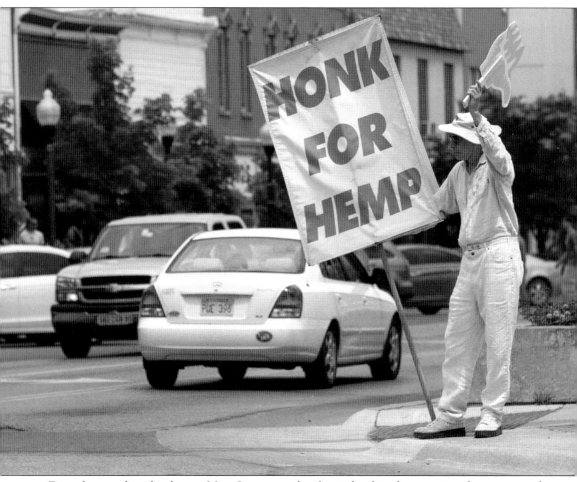

For as long as there has been a Mass Street, people of varied political perspectives have expressed their ideas. By and large, they have been encouraged to do so and have been not only tolerated, but also cherished for making Mass Street distinctive. A modern example was Tom Trower. Every weekend for three decades, he dressed in hemp clothing, put on his hemp bracelets, and took his "Honk for Hemp" sign to Mass Street. Trower would position himself on a busy corner and enthusiastically ask for motorists to endorse his passion for the freedom to grow all types of hemp with a quick tap on the old car horn. For this, he earned the moniker "Honk for Hemp Guy" and joined the still-growing group of people whose outsized efforts, personalities, or quirks make them stand out on Mass Street. (Courtesy of the *Lawrence Journal-World*.)

Nine

MARCHING

Much like a scrapbook of family photographs, the pictures of parades and protests that have happened on Mass Street relate what was foremost on the minds of the citizens of Lawrence in years past. Parades and protests require organization, so the issues and commemorations represented must be important enough for participants to devote time to them. Both require permits as well. At some level, city leaders have given their go-ahead that, yes, this group deserves to be seen and heard.

Sara Robinson mentioned a parade on Mass Street on July 4, 1855, in her book *Kansas: Its Interior and Exterior Life*. This was likely the first Mass Street parade, a patriotic production attended by 1,500 people. Since then, annual parades celebrating the University of Kansas homecoming and Veterans Day passed down Mass Street. Parades celebrating anniversaries of the founding of Lawrence or of Haskell Institute unspooled at 25-year intervals. Parades commemorating accomplishments such as the return of troops after the Philippine-American War brought out the bunting episodically.

Some parades ran north to south and others south to north for reasons unknown. Thematic parades such as horse-drawn carriages at Christmas, zombies at Halloween, and Irish motifs for St. Patrick's Day began in the 1990s. Protests on Mass Street deserve their place as well, especially the antiwar protests of the 1960s and 1970s that garnered national attention.

While Mass Street protests and parades do not always include as tightly scripted a production as the Rose Parade or the over-the-top multiday party of the Mardi Gras parade in New Orleans, there is no doubt the diversity, passion, creativity, and general joie de vivre regularly processing on Mass Street mirrors the community that claims Mass Street as its own.

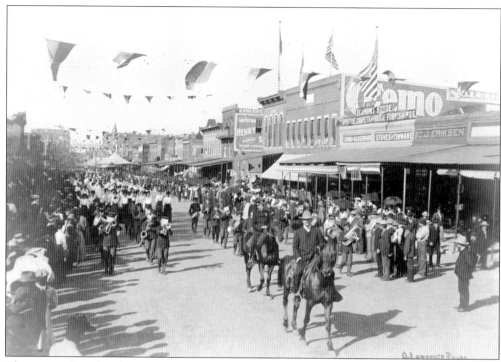

Above, marching bands and mounted horsemen pass the five-year-old Eriksen Building (center right) during the October 6, 1904, semicentennial parade. The Parker Amusement merry-go-round below the Merchants National Bank clock tower (center left) attracted children to Ninth and Mass Streets, and fluttering banners stretched between downtown buildings. The weeklong celebration included a speech from Susan B. Anthony advocating women's suffrage and a mile-long procession of hundreds of schoolchildren and their teachers waving American flags. Mass Street was so crowded that people had to elbow their way through. Below, a dozen pachyderm promoters from the Barnum & Bailey Circus lumber down Mass Street to announce the night's performance. The horse carriages and automobiles along the curb mark this parade in the early 1900s. (Above, courtesy of the Douglas County Historical Society, Watkins Museum of History; below, courtesy Kenneth Spencer Research Library, University of Kansas.)

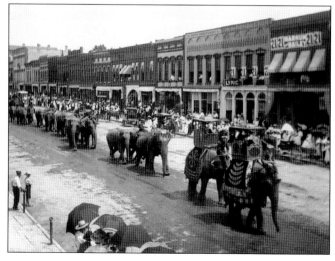

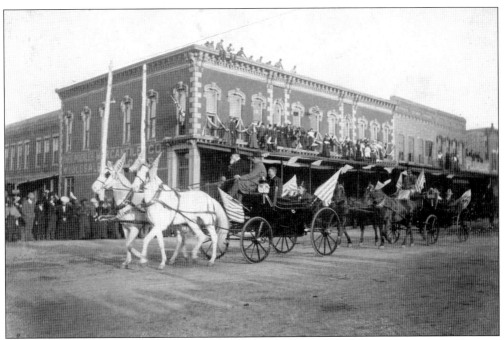

Pres. Teddy Roosevelt stood and waved to some of the 15,000 people lining Mass Street during a brief carriage ride on May 7, 1903, while his campaign train stopped at the Union Pacific depot. Spectators clambered onto the awning and roof of Poehler's Mercantile at Ninth and Mass Streets for a better view. (Courtesy of the Douglas County Historical Society, Watkins Museum of History.)

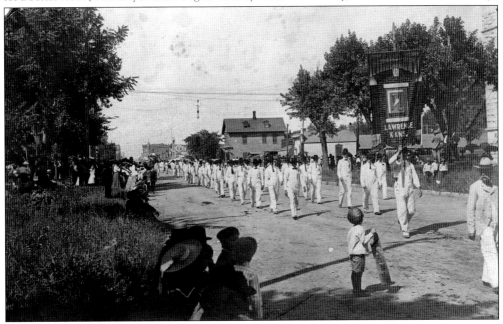

Behind a banner displaying their tools of the trade, members of the brick and stone masons union march past the new Douglas County Courthouse, far right, during a parade between 1905 and 1910. Trade unions and fraternal aid organizations commonly took part in community parades. (Courtesy of the Douglas County Historical Society, Watkins Museum of History.)

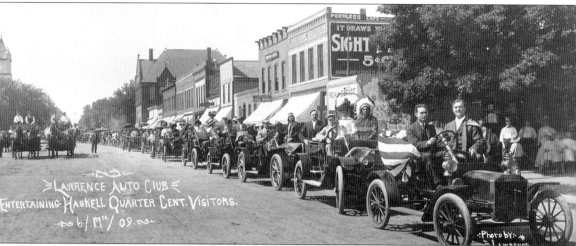

An afternoon procession of 25 automobiles down Mass Street was the highlight of a parade on October 14, 1909. It commemorated the 25th anniversary of Haskell Institute and featured the vehicles of the Lawrence Automobile Club and members of the Kansas Fraternal Aid Association. After the parade, the company of roadsters ascended Mount Oread to tour the University of Kansas and then drove to Haskell Institute. The Fraternal Aid Association was founded in Lawrence in 1890 as a social group that was a forerunner of life insurance companies. Members pooled their risks and guaranteed certain monetary payments to members' surviving beneficiaries. Membership was available only to Whites between ages 18 and 55 and excluded people in hazardous occupations, residents of cities larger than 200,000 people, and everyone in the South. Its annual meeting was held in the association building at Eighth and Vermont Streets. (Courtesy of the Douglas County Historical Society, Watkins Museum of History.)

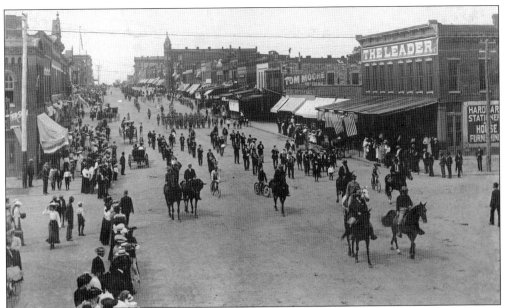

Children on decorated bicycles and a band escort Company H of the Kansas 20th Volunteer Infantry during their parade down Mass Street on November 4, 1899. Company H included Lawrence-area men who had fought in the Philippine-American War from February to October 1899. (Courtesy of the Douglas County Historical Society, Watkins Museum of History.)

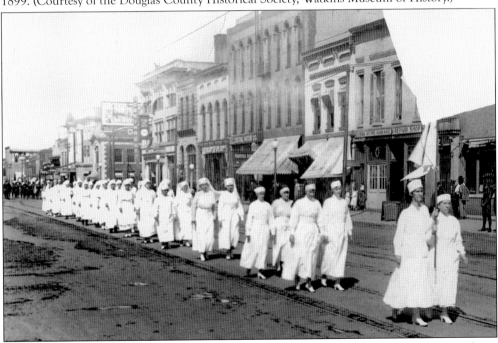

A group of 40 women, perhaps American Red Cross nurses, march in the April 5, 1918, Liberty Bond parade. This was part of a three-day community effort to motivate people to buy government bonds to support the military during World War I. The women marched from South Park to the Bowersock Opera House, with rain drenching them as they arrived for the speeches. (Courtesy of the Douglas County Historical Society, Watkins Museum of History.)

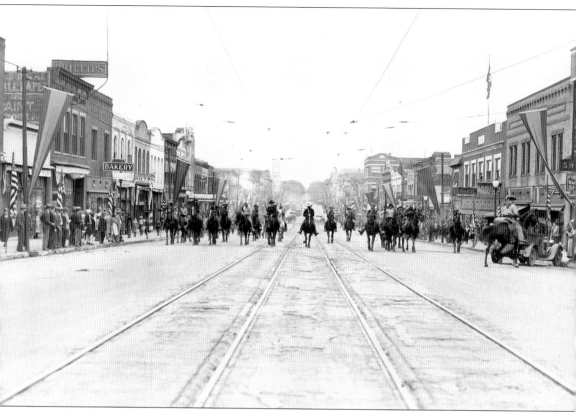

A three-day celebration of the 75th anniversary of Lawrence began on October 10, 1929, and included an elaborate list of events that took six months to plan. First, horsemen from the Cattlemen's Protective Association, shown here costumed as border raiders, pretended to rob Mass Street businesses. That evening, blazing torches were lighted on the roofs of the Eldridge Hotel, Weaver's, and Round Corner Drug. The flames and blinding smoke reminded townspeople of the fiery destruction of Quantrill's Raid. The next day, Donald Swarthout, the University of Kansas dean of fine arts, directed vintage musical performances along Mass Street. Ceremonies were held and political speeches delivered to dedicate the new Lawrence airport and the new Robinson Park, where *In Zhuje Waxobe* sat on its two-week-old concrete and stone pedestal with a new plaque fixed to its east face. A two-mile-long Pageant of Progress parade concluded the festivities. Both Haskell Institute and the University of Kansas played home football games. (Courtesy of the Douglas County Historical Society, Watkins Museum of History.)

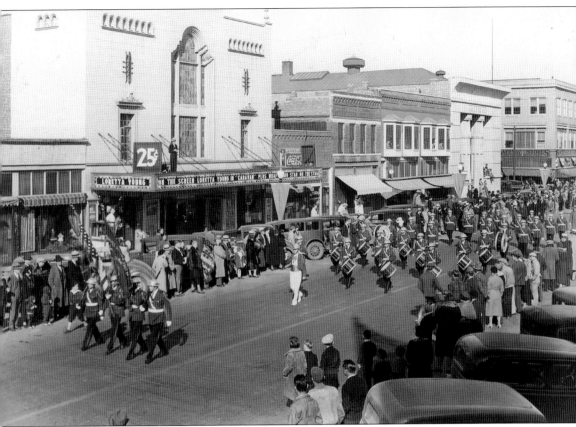

Drummers tap out the cadence in front of the Varsity Theater in this parade celebrating the 50th anniversary of Haskell Institute in 1934. The streetcar tracks are gone, and cars line the route. The Varsity, like all Mass Street movie theaters at that time, was racially segregated. The buildings at the far right are the Masonic Temple at 1001 Mass Street and the three-story J.C. Ecke building at 945–947 Mass Street. The First Methodist Church was at 1001 Mass Street until 1891, when it moved to its new building at 946 Vermont Street and the old church was bought by J.B. Watkins. That building was removed, and the Masonic Temple was built in 1910 in the Egyptian Revival style. It was the only commercial building designed by University of Kansas art and architecture professor William A. Griffith. The Ecke building with the Safeway grocery store across the street was constructed in 1908. (Courtesy of the Douglas County Historical Society, Watkins Museum of History.)

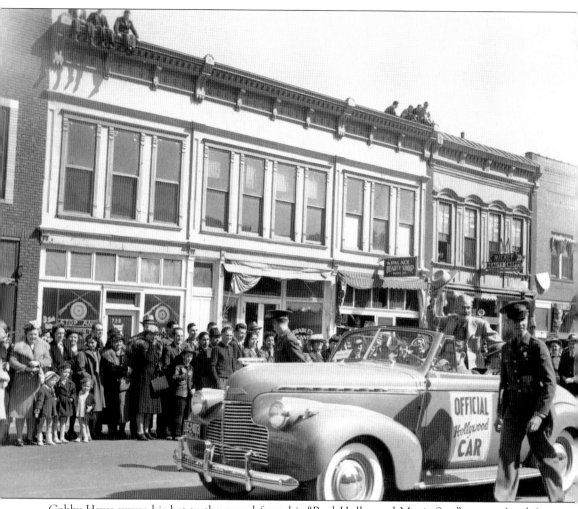

Gabby Hayes waves his hat to the crowd from his "Real Hollywood Movie Star" car on April 4, 1940. Hayes was joined by costars June Story, Wendy Barrie, Ona Munson, John Wayne, Walter Pidgeon, Roy Rogers, and Gene Autry in this parade promoting the world premiere of the movie *Dark Command*, a Western loosely based on the story of Quantrill's Raid. An estimated 70,000 people lined Mass Street or perched along roof edges to watch the parade of 400 horses, historic carriages, and a dozen cars. The Dickinson, Varsity, Granada, and Orpheum theaters on Mass Street all premiered the movie that night. In the evening, an Army cavalry acted as Quantrill's raiders while a Hollywood special effects expert burned a replica of the Eldridge Hotel in South Park. The Hollywood entourage took over the entire second floor of the Eldridge Hotel. (Courtesy of the Douglas County Historical Society, Watkins Museum of History.)

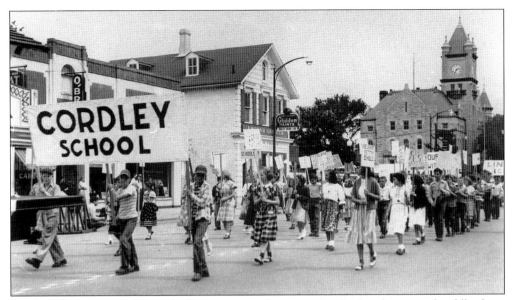

Cordley Elementary and Lincoln Elementary students wearing loafers, boots, and saddle shoes march during a 1940s-era parade. Their afternoon stroll up Mass Street past the courthouse was an effort to lobby adults for a yes vote on a school bond election. (Courtesy of the Douglas County Historical Society, Watkins Museum of History.)

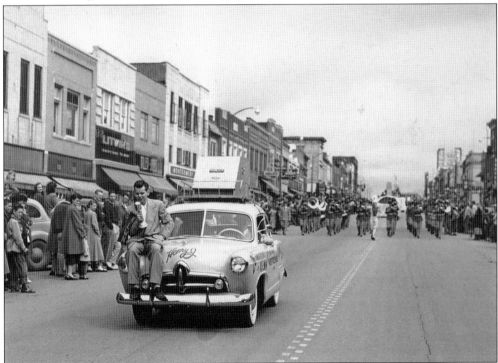

A bumper-riding radio announcer from then-new local station KLWN broadcasts during this parade in the 1950s. A band and float follow, possibly from the University of Kansas homecoming parade. The 1931 Art Deco front of the Montgomery Ward store, 825–827 Mass Street, is seen left of center. (Courtesy of the Kenneth Spencer Research Library, University of Kansas.)

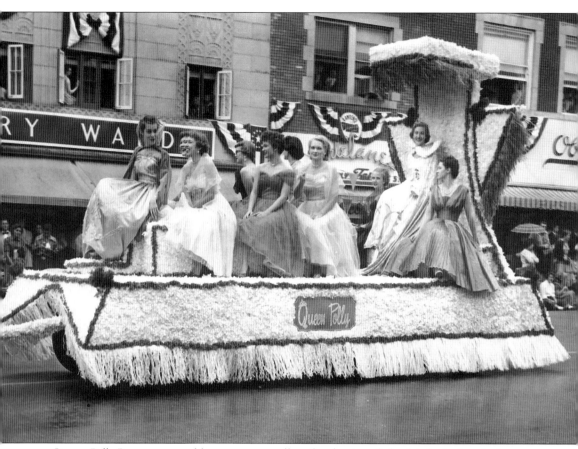

Queen Polly Peppercorn and her court were all smiles despite a light drizzle during the Lawrence centennial parade on September 25, 1954. Fifty thousand people watched as 57 high school bands, 350 horses, 20 marching groups, and 40 floats processed down Mass Street in 80 minutes. The floats depicted events and themes from the first 100 years of Lawrence's history. A pageant about Lawrence, *Trails West*, had six nights of performances at Haskell Stadium. It was purchased from the John B. Rogers Company, which was in the business of writing and producing musical theatrical depictions of town histories. Gladys Six, the drama teacher at Central Junior High, cast 900 local actors for the extravaganza, which included a simulated nuclear explosion. A log cabin in South Park was the ticket office. There was a midway set up in South Park, and people enjoyed daily circus calliope concerts there. (Courtesy of the Kenneth Spencer Research Library, University of Kansas.)

On November 11, 1968, the American Legion color guard, shown above, headed the annual Veterans Day parade, beginning at the post office and marching south down Mass Street to South Park. Every light pole held an American flag. Thirty minutes after that parade, a group of anti-war protesters, shown below, from the Students for a Democratic Society, also bearing an American flag, started at South Park and marched north up Mass Street. No violence occurred, but that day marked the end of Veterans Day parades in Lawrence for 50 years. (Above, courtesy Kenneth Spencer Research Library, University of Kansas; below, courtesy of the Douglas County Historical Society, Watkins Museum of History.)

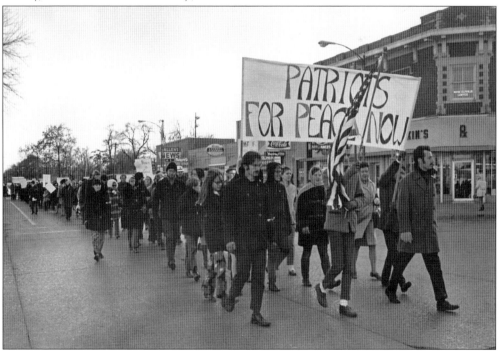

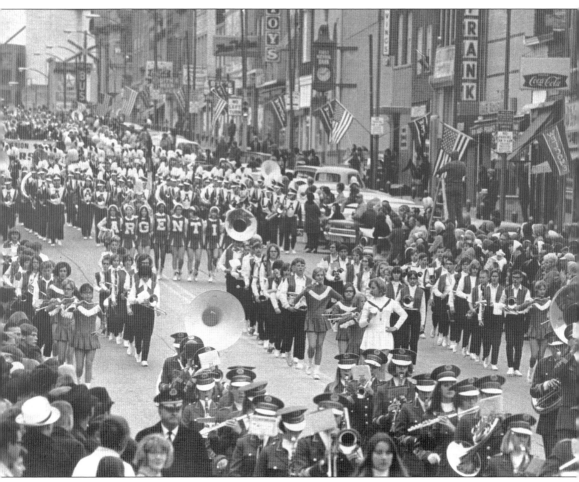

The Argentine High School band (center) from Kansas City, Kansas, passes the First National Bank, 746 Mass Street, during the Band Day parade on November 1, 1969. It was one of 84 high school bands marching down Mass Street that day. For 70 years, area high schoolers followed the tradition of rising before dawn for a frigid fall morning boarding of buses for the trip to Lawrence. Led by the University of Kansas marching band, they marched down Mass Street past thousands of spectators. The school buses then carted them to Memorial Stadium for the football game and a halftime performance by the massed bands. The day introduced untold numbers of high schoolers to the university. The last Band Day parade was in 2017, canceled by budget constraints and television broadcast schedules that would have started the parade in the early morning in order to accommodate an 11:00 a.m. game time. (Courtesy of the Kenneth Spencer Research Library, University of Kansas.)

Rick Dowdell, a Black Lawrence teen, was shot and killed by a Lawrence police officer on July 16, 1970. Four days later, Nick Rice, a White Leawood teen, was shot and killed by a Lawrence police officer. The community was on edge, as there had already been three nights of martial law in Lawrence that April. Episodes of gunfire and arson continued. Dowdell's funeral procession is pictured here as mourners prepare to cross Mass Street on July 23, 1970. Television news reporters are at the front of the procession near the carriage, which was pulled by two ponies. The funeral took place the same day as the annual downtown sidewalk sale. Shoppers moved aside to let the funeral cortege pass through on its way down Ninth Street to St. Luke AME Church. At the service, Dowdell's father called for peace. That week, violence was markedly reduced, and the relative peace continued the rest of the summer. (Courtesy of the Kenneth Spencer Research Library, University of Kansas.)

Lawrence put on an 80-minute parade on June 14, 1976, to celebrate the nation's bicentennial. The spectacle included Uncle Sam on roller skates, marching bands, and local children. The festivities continued in South Park with the Douglas County Fiddling and Picking Championship. (Courtesy of the Douglas County Historical Society, Watkins Museum of History.)

In this 2003 photograph, local guitarist and physician Joe Douglas leads a song protesting the war in Iraq in front of the Douglas County Courthouse. Other protesters marched in South Park and on Mass Street, dressed in black and carrying banners and mock coffins. (Courtesy of the Douglas County Historical Society, Watkins Museum of History.)

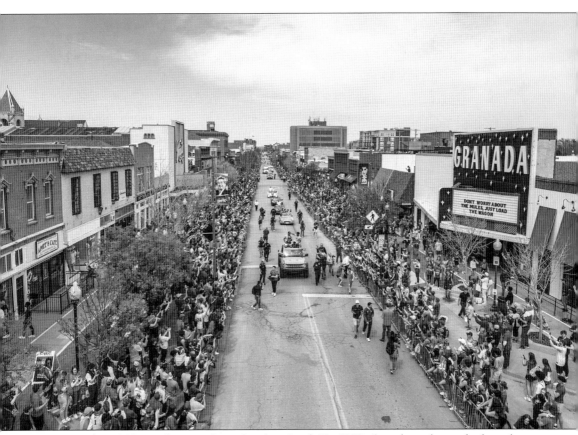

An estimated 70,000 people turned out Sunday, April 10, 2022, for a long, loving look at the University of Kansas national champion men's basketball team. Fans lined up as many as 15 deep in some places along the Mass Street parade route from Sixth Street to Nineteenth Street. Six days earlier, a completely spontaneous celebration unfolded on Mass Street when a crazy, joyful, screaming mob gathered immediately after the Jayhawks' come-from-behind victory over North Carolina in the championship game. Open container laws were relaxed, and peaceful celebrations were encouraged, as long as the light poles and trees were not ascended. In this picture, under a fair Kansas sky, the Granada marquee sports the team's mission statement from coach Bill Self's father, who had passed away three months earlier. Bill Self Sr. was famous for his advice, "Don't worry about the mules, just load the wagon." (Courtesy of Kansas Athletics.)

DISCOVER THOUSANDS OF LOCAL HISTORY BOOKS FEATURING MILLIONS OF VINTAGE IMAGES

Arcadia Publishing, the leading local history publisher in the United States, is committed to making history accessible and meaningful through publishing books that celebrate and preserve the heritage of America's people and places.

Find more books like this at
www.arcadiapublishing.com

Search for your hometown history, your old stomping grounds, and even your favorite sports team.

Consistent with our mission to preserve history on a local level, this book was printed in South Carolina on American-made paper and manufactured entirely in the United States. Products carrying the accredited Forest Stewardship Council (FSC) label are printed on 100 percent FSC-certified paper.